MW01492847

IMAGES
of America

MODERN SAN RAFAEL
1940–2000

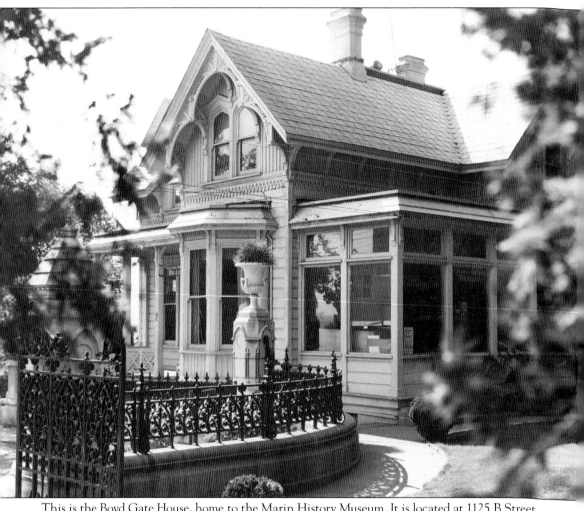

This is the Boyd Gate House, home to the Marin History Museum. It is located at 1125 B Street in San Rafael and features rotating exhibitions and educational programs relating to Marin County's deep and diverse history. (Courtesy of Marin History Museum.)

ON THE COVER: The Marin County Mounted Sheriff's Posse parade makes its way down Fourth Street in May 1964. (Courtesy of Marin History Museum.)

IMAGES
of America

MODERN SAN RAFAEL
1940–2000

Marin History Museum

ARCADIA
PUBLISHING

Published by Arcadia Publishing
Charleston, South Carolina

Printed in the United States of America

Library of Congress Control Number: 2011938567

For all general information, please contact Arcadia Publishing:
Telephone 843-853-2070
Fax 843-853-0044
E-mail sales@arcadiapublishing.com
For customer service and orders:
Toll-Free 1-888-313-2665

Visit us on the Internet at www.arcadiapublishing.com

*To our Marin History Museum members and volunteers
whose support makes projects like this book possible*

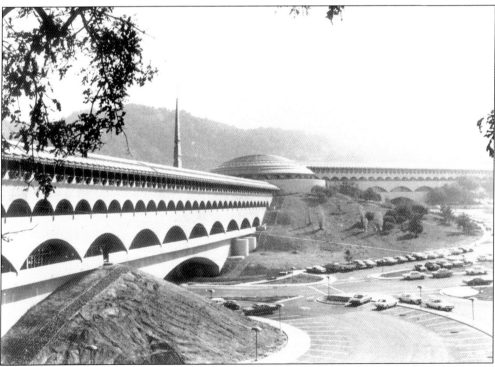

The Marin County Civic Center, designed by Frank Lloyd Wright, is a national and state landmark. (Courtesy of Marin History Museum.)

CONTENTS

ACKNOWLEDGMENTS

The Marin History Museum would like to acknowledge and thank staff members Jocelyn Moss and Michelle Sarjeant Kaufman for the energy they brought to the creation of this book. They volunteered their time and expertise to select photographs, research captions, and write about San Rafael's modern era. Additionally, museum members Bruce Schwarze and Bill Kaufman spent hours of their time researching, writing, and scanning images so this book could be completed. Without their help, this book would not have been possible.

The museum's extensive collection of photographs and negatives would not exist if not for the kindness and generosity of county residents who had the foresight to recognize the importance of their photographs and snapshots. This book relies heavily on images drawn from the museum's *Independent Journal* photography collection, for which the staff is grateful. In addition, the authors pulled from the museum's Roy Farrington Jones Collection of photographs so readers could see an image of the B Street Station and the fires on Fourth and D Streets and at the Municipal Baths.

Historians, both past and present, have contributed significantly to this book through their writings, oral histories, and individual collections. The Marin History Museum wishes to thank the following individuals for their contributions to this book: Fred Codoni, Jean Starkweather, and John McNear. Each of you gave your time and knowledge freely so this book would be accurate. Laurie Thompson and Carol Uhrmacher from the Anne T. Kent California Room of the Civic Center Branch of the Marin County Free Library were exceptionally helpful with research. Finally, three institutions helped in the creation of this book: the Marin Municipal Water District, Mary E. Silveira Elementary School, and the San Francisco History Center in the San Francisco Public Library.

Unless otherwise indicated, all images used in this book are from the collection of the Marin History Museum.

INTRODUCTION

On May 27, 1937, the Golden Gate Bridge opened with fanfare and parades. Little did anyone know the huge impact it would have on Marin County and on San Rafael specifically. Families began buying homes, but times were hard, the Depression lingered, and World War II was right around the corner. War time shortages put a halt on building projects, and residents focused their energy on the war effort with activities, such as civil defense, scrap drives, victory gardens, and rationing. Every week, the newspaper printed a list of young men drafted into the Army.

Businesses encouraged their employees to buy war bonds and then advertised the percentage of their employees who had participated in war bond drives. Housing became scarce as war workers and military men moved into Marin County. As a result, many private homes boarded young men and women who worked in the war effort. Sadly, many families learned that their loved ones were lost in the war.

Finally, V-J Day came, and the war ended. There was a party and parade on Fourth Street where homemade confetti was thrown, as residents rejoiced in the street. With the servicemen home, life resumed at a more normal pace.

Through the war years and then into the 1950s, San Rafael maintained its supremacy, as Marin's shopping center with anchors, such as Albert's Department Store, J.C. Penney, Woolworth's, and Montgomery Ward as well as local hardware, food, butcher, shoe repair, and five-and-dime stores that filled out the list of San Rafael merchants.

With the war over and the Golden Gate Bridge offering easy access to San Francisco, San Rafael began to boom. Developers eyed the vast acres of land to the east and north of town, coveting the pastureland for housing tracts. The San Pedro peninsula was quickly identified as an enviable place to live. The ranches were sold, and in their place sprung up shopping centers and neighborhoods like Glenwood, Loch Lomond, and Peacock Gap.

To the north of San Rafael, the Freitas Ranch, the Miller Ranch, and the area around Gallinas Creek were transformed into the neighborhoods of Terra Linda, Marinwood, and Santa Venetia. The Freitas Ranch, just west of Highway 101, was sold to developers who built Alliance, Kenney, and Eichler homes. Just north of Terra Linda, Marinwood was originally the historic Miller Ranch, which Gerald Hoyt bought and developed in 1955. Soon after the houses came the need for new roads, schools for the children, and shopping areas. Northgate Shopping Center was built in 1964 in Terra Linda. It offered easy access from Highway 101, and its acres of free parking quickly overshadowed the old downtown.

Just as suburbs were growing, so was the city government. The old courthouse on Fourth Street was suddenly out of date and out of space. The city purchased the Scettrini Ranch in 1956 for just over $500,000. Located north of central San Rafael and east of Highway 101, the site was spacious enough to accommodate the growing needs of the county. County supervisor Vera Schultz and planning director Mary Summers suggested Frank Lloyd Wright be contracted to design the new buildings. After some difficulties, initial plans for the Marin County Civic Center were complete

by 1958. Although he passed away before its completion, Frank Lloyd Wright left the project in the capable hands of Aaron Green and William Wesley Peters.

The Marin County Civic Center buildings were constructed in stages. The first structure completed was the Administration Building, dedicated in October 1962, followed by the Hall of Justice in 1969, and finally the Veterans' Memorial Theater, which opened with a gala performance by the Marin Symphony in 1971. The buildings were immediately a tourist attraction.

Today, anyone walking in downtown San Rafael will notice the many historic homes and buildings that connect the city to its past. However, this was not a foregone conclusion, and if not for a concerted effort to preserve older structures, the city would not be what it is today.

Local residents formed the Cultural Affairs Committee so buildings and homes in San Rafael would be recognized for their historic value. Because of these efforts, structures, like the Dollar home, now known as the Falkirk Cultural Center, were saved. The remodeling and preservation of the Rafael Theater was also an effort of the residents. Both these projects have added immensely to San Rafael's vibrant cultural life. However, other buildings, such as the First Presbyterian Church and the old El Camino Theatre, were razed and gutted. Fire also obliterated historically significant buildings, changing the face of the city forever. But in the empty spaces, new buildings appeared, like the entire 1400 block of Fourth Street.

Time travelers from the 1940s would be amazed at all the changes in the little town they once knew. And yet, some of the old places still remain to give our city a historic foundation.

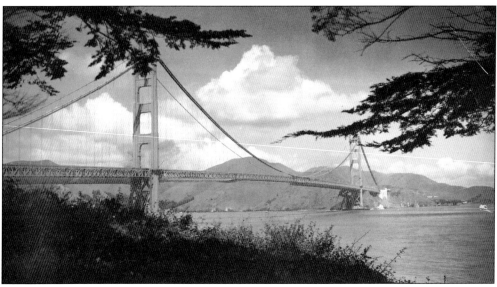

The Golden Gate Bridge is seen from the San Francisco Presidio with Marin County in the distance.

One

SAN RAFAEL AS IT WAS
1940s–1950s

When the Golden Gate Bridge opened in 1937, all of Marin County was poised for development. However, the lingering effects of the Depression and then World War II made progress slow. Marin threw itself into the war effort as men were called away to military service. Families supported the effort with victory gardens and by rationing gasoline, butter, and sugar. Blackout curtains and other restrictions became a way of life. Following World War II, San Rafael's local businesses reigned supreme because every service was available on Fourth Street and Fifth Avenue. Anchored by Albert's Department Store and many other merchants, such as J.C. Penney, Woolworth's, and Montgomery Ward, the shopping area of San Rafael was a bustling place. Local hardware, food, butcher, shoe repair, and five-and-dime stores filled out the list of San Rafael merchants. San Rafael was the seat of Marin County government, and every resident had some reason to visit the courthouse on Fourth Street. This was the scenario of a small town about to change.

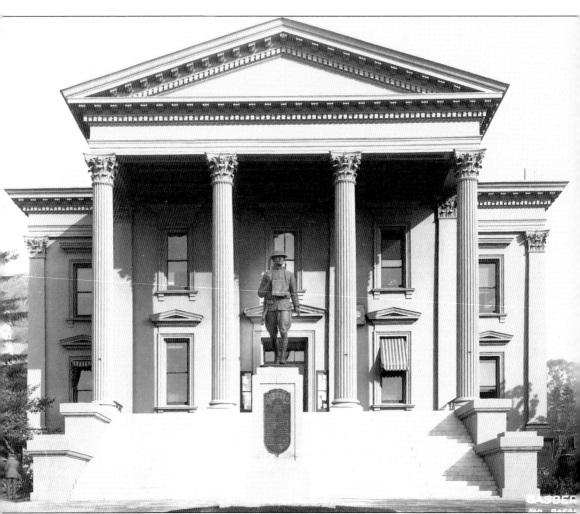

The cornerstone for the Marin County Courthouse was laid in 1872, and the county took great pride in its grand Grecian-style courthouse. However, as the county grew, so did the needs of its residents. Soon, an expansion of the building became necessary. In 1949, the building was remodeled, adding more room for offices. Then again in 1958, an addition was made to the building to accommodate the county's increased demand. The basement of the courthouse was also the first home of the Marin County Free Library, with an entrance on the side of the building. The courthouse was the heart of Fourth Street; many speeches were given from its steps, innumerable parades marched by, and students from the local high schools skipped class to march to the courthouse steps and protest the Vietnam War in 1968.

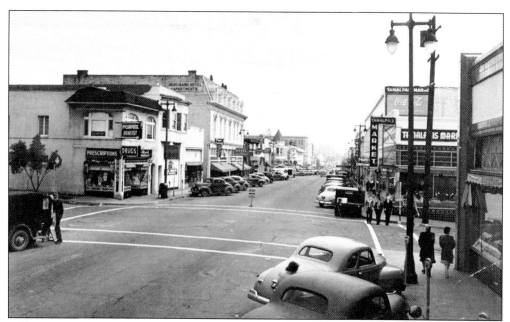

Following World War II, San Rafael's Fourth Street was the main shopping area for the entire county. There were movie theaters, department stores, furniture stores, hardware shops, and variety stores. Shoppers came from all the towns in Marin to take advantage of the assortment of stores on Fourth Street. Many restaurants on Fourth Street provided a place to sit and enjoy a meal or a cigarette and a cup of coffee.

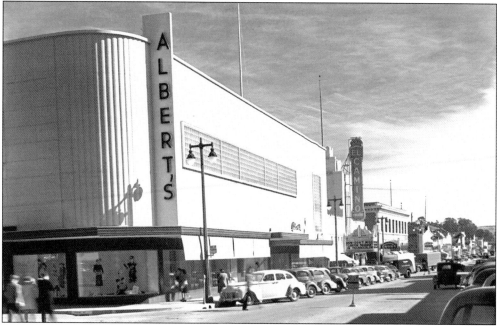

When Albert's Department Store opened on October 14, 1942, this three-story emporium at Fourth and Court Streets was the largest store in the county and Jacob Albert's fifth store. Albert was a civic leader in San Rafael as well. He served on the San Rafael City Council, donated Albert's Field to the city, and also donated the lot and money for a Boy Scouts building.

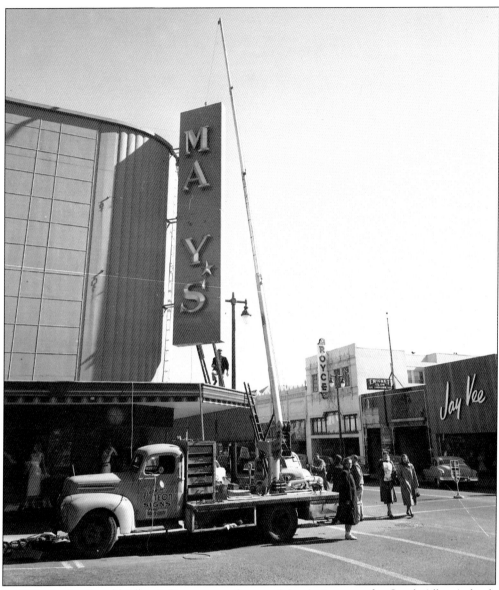

In 1952, the family sold Albert's Department Store to Macy's six years after Jacob Albert's death in 1946. The next year, Macy's opened its doors to the public on February 24. The store was an anchor of Fourth Street and drew shoppers from all over the county. As business grew, Macy's recognized the increased need for space and purchased neighboring buildings on the north side of the street. The adjacent buildings were connected on the inside so shoppers could easily move between departments. Later, Macy's expanded to two additional storefronts on the south side of Fourth Street. As a result of the development of local malls, Macy's closed its retail clothing departments in 1992 and sold only household goods from Fourth Street. Then in 1996, Macy's phased out its downtown San Rafael location, leaving many empty storefronts.

Parades down Fourth Street were a regular holiday tradition. This parade in the 1940s passes the J.C. Penney store and features a battleship float, showing the preoccupation with World War II.

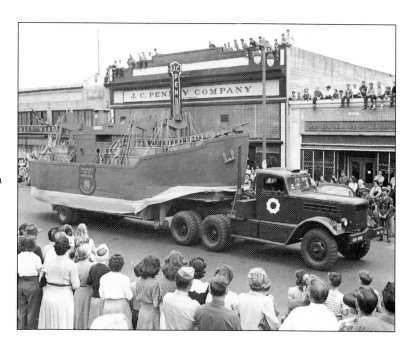

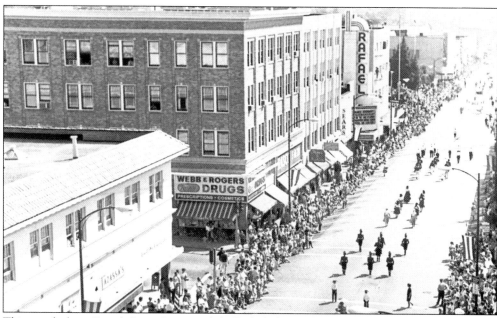

This parade down Fourth Street has passed the Rafael Theater (in the upper right of the photograph). The Rafael was built in 1938 after the Orpheus Theater on the same site had burned. Architect S. Charles Lee designed the building in the Art Deco style with its iconic neon marquee. The Rafael fell on hard times, and the theater was closed entirely after the 1989 Loma Prieta earthquake.

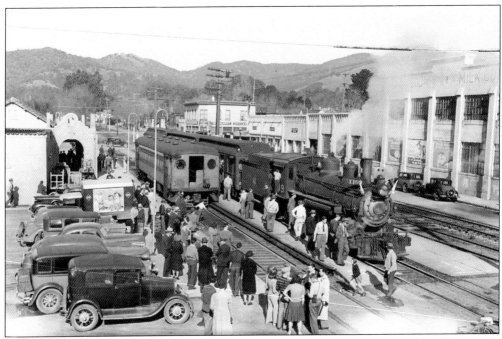

The last commuter train left San Rafael in 1941. Pictured is the train leaving the station on its last run. The tracks remain waiting for the next train to appear.

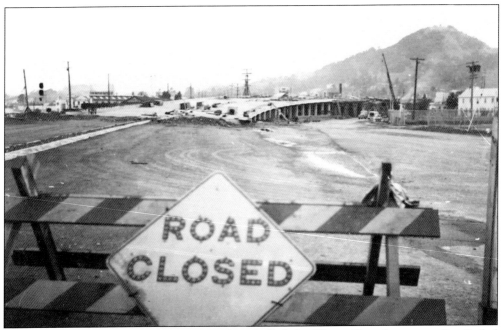

The 1941 opening of the Highway 101 viaduct (called the "flyover") in downtown San Rafael was an important breakthrough for automobile traffic. Formerly, traffic had backed up in city streets. The viaduct allowed the traveler to bypass downtown San Rafael and travel north without stopping at every traffic light.

After Pearl Harbor, the military draft became a reality. Young men throughout Marin County were called up for service. They prepared to leave for training, and the scene of this photograph was repeated all over Marin. Recruits or volunteers had their photographs taken with their families before leaving for an unknown future.

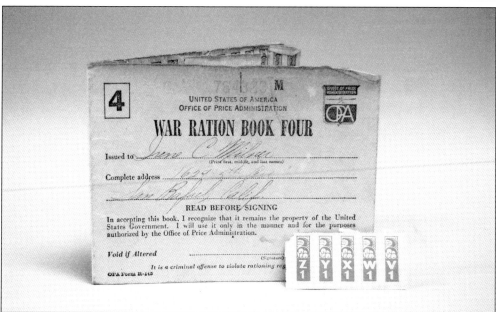

San Rafael residents were regulated in their purchases by government rationing. Everyone made sacrifices. Certain goods, such as meat, butter, sugar, gasoline, tires, and fuel oil, were rationed. Every family was issued rationing books at their local school and used them to purchase the items allowed by the rationing system. Rationing was a way to make shortages fair for all civilians. The practice ended in 1946.

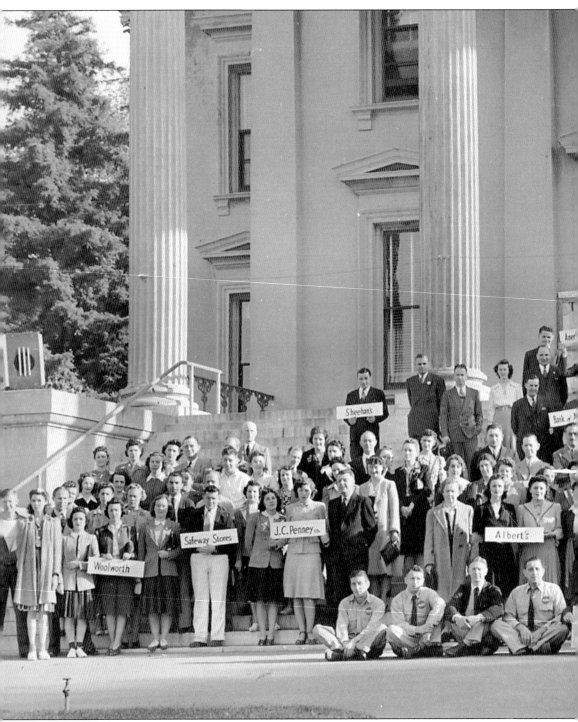

War bonds were a patriotic way for those on the home front to help the war effort. A friendly competition to publicize the number of war bonds their employees purchased grew among the businesses in downtown San Rafael. Local San Rafael businesses gather in 1942 on the courthouse steps to proclaim that all their employees had pledged to buy war bonds. Every day, the local

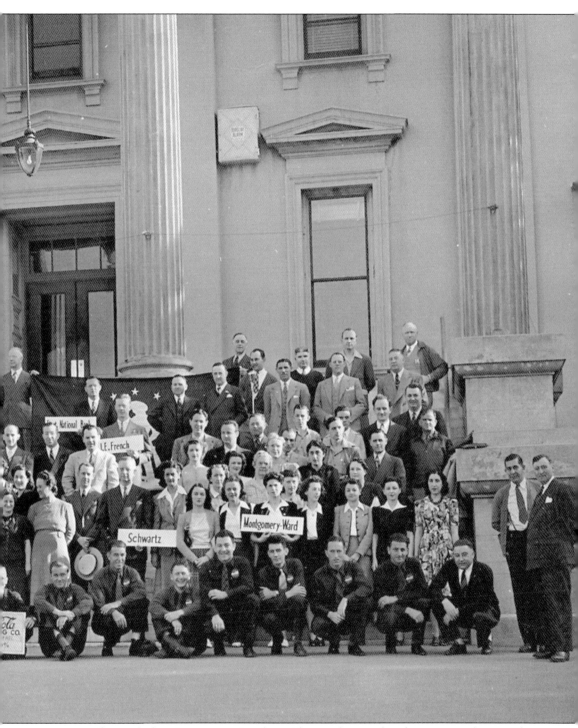

newspapers featured advertisements urging the residents to buy war bonds to support the war. The businesses represented here are Woolworth's, Safeway, J.C. Penney, Albert's, Coca-Cola Bottling, Schwartz, Montgomery Ward, Bank of America, American Trust, First National Bank, J.E. French Motor Cars, and Sheehan's Auto Supply.

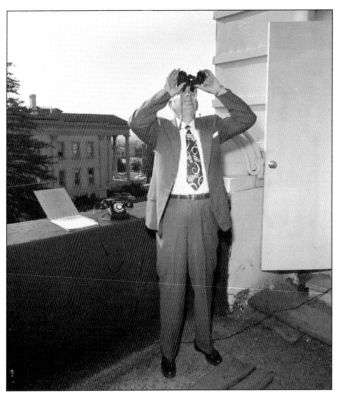

A civil defense volunteer scans the skies for incoming planes. On June 14, 1954, San Rafael, along with other Bay Area cities, held an air-attack test to prepare residents for response to a Soviet attack. During the Cold War (1954–1979), an imminent attack was expected, and residents participated in drills to prepare for their roles in an actual assault.

A Nike missile base was constructed on Smith Ranch Road in 1956. The missiles were to intercept incoming attacks by the Soviets. The first missiles were the Nike-Ajax with a range of 25 miles. Later, a Nike-Hercules missile with a range of 90 miles was installed. The missiles could carry a nuclear warhead. By 1970, the missile bases were decommissioned.

Two

A Waterfront Wonderland

A Tour of San Pedro Peninsula

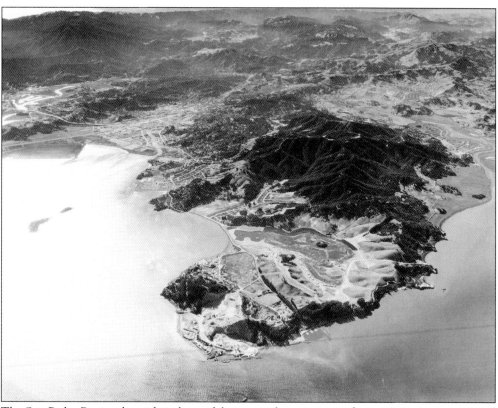

The San Pedro Peninsula, with its beautiful views and proximity to the water, invite recreational boating, fishing, and swimming. To tour the peninsula, visitors can drive east on Second Street where the Montecito Shopping Center on the right is backed by the San Rafael Canal. The canal is lined with water- and boating-related businesses. Shortly, the road becomes San Pedro Road and passes the hilly neighborhoods of Glenwood, Loch Lomond, and Peacock Gap. The road curves inward at McNear's Brickyard, and the San Rafael Rock Quarry then continues on to McNear's Beach, a Marin County park. The road becomes North San Pedro Road, bisecting China Camp State Park before reaching the Santa Venetia neighborhood. This trip encircles the whole San Pedro Peninsula. The glorious views of the bay, the wildlife sightings, and the abundance of open space make this area a haven for nature lovers.

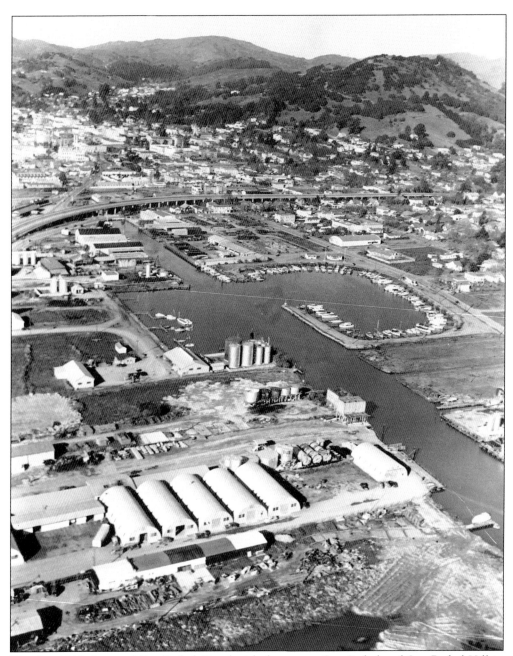

This late-1940s image of San Rafael Canal with downtown San Rafael and San Rafael Hill in the distance clearly shows the San Rafael Municipal Yacht Harbor in the center. The Municipal Yacht Harbor was constructed in 1941 on San Pedro Road across the street from San Rafael High School. It provided public yacht facilities with berths for 34 boats safely tucked away from the more turbulent waters of the San Francisco Bay. Amid the city's building boom of the 1950s, the yacht harbor was sold. In 1955, the Montecito Construction Company purchased the area, filled in the harbor, and began development on a new shopping center. That shopping center would become known as the Montecito Shopping Center, later changed to the Montecito Plaza Shopping Center.

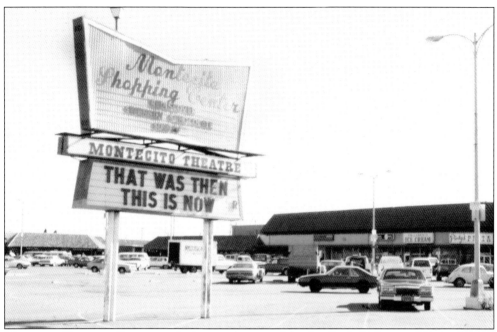

Montecito Shopping Center was built over the site of the San Rafael Municipal Yacht Harbor in 1962. The photograph shows the center in 1985 when it was becoming run down. *That Was Then . . . This Is Now*, starring Emilio Estevez and Craig Sheffer, is playing at the Montecito Theatre. A 1988 renovation with Mission-style architecture updated the center and attracted more businesses. The movie theater closed in 1989.

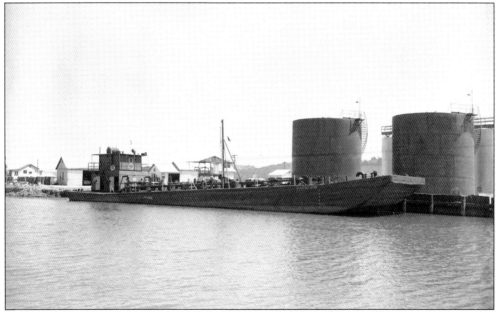

Much of the southern shore of San Rafael Canal is fronted by manufacturing and automobile businesses. However, in the 1960s, low-interest loans became more readily available, and the result was a low-income-housing building boom. The resulting neighborhood is a mix of residential and commercial properties and is known as the Canal.

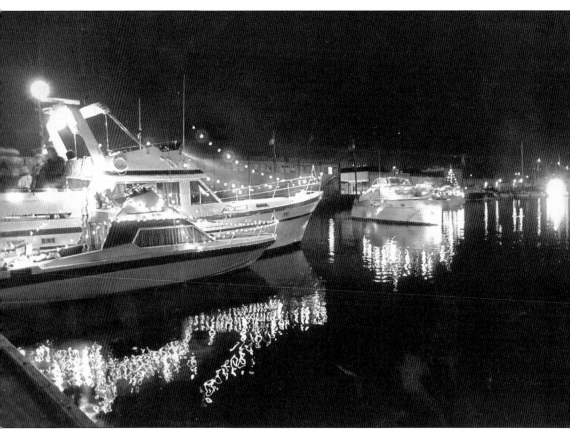

The San Rafael Canal is deep enough to allow boats to come in from San Pablo Bay and the Greater San Francisco Bay. Boaters will notice that the north shore of the canal is lined with boating-related businesses, yacht harbors, and farthest west, the Montecito Plaza Shopping Center. Beginning in 1979, spectators have been delighted by the annual Parade of Lights along the Canal. Boat owners from all over the county devote hours and hours preparing their boats. The above photograph shows some of the decorated participants at night on the canal. The best viewing locations for the parade are said to be at Pickleweed Community Center, Beach Park, and along the canal area behind the Montecito Plaza Shopping Center. Some say San Rafael's Parade of Lights is one of the largest lighted boat parades in the Bay Area.

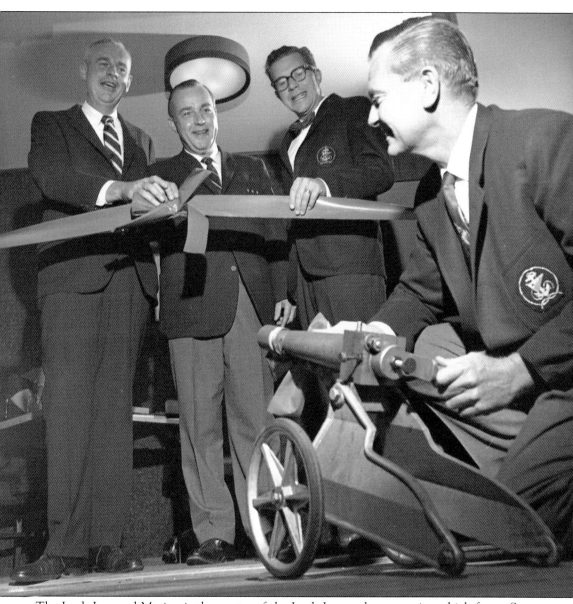

The Loch Lomond Marina is the center of the Loch Lomond community, which fronts San Pablo Bay. The photograph was taken in November 1964 when the Loch Lomond Yacht Club opened its new headquarters. The participants are, from left to right, state senator John ("Jack") F. McCarthy, Commodore Carroll Stoerker, Mayor John McGinnis, and fleet captain Lew Glaeser. The McCarthy family founded the Loch Lomond Marina in the early 1950s. They continued to run the enterprise for the next 40 years. Since its inception, the marina has undergone extensive renovations and upgrades. Loch Lomond is one of the few remaining marinas in San Rafael and one of the largest in the North Bay, as it can accommodate over 500 vessels. State senator Jack F. McCarthy was posthumously recognized for his civic work when the Richmond–San Rafael Bridge was named in his honor.

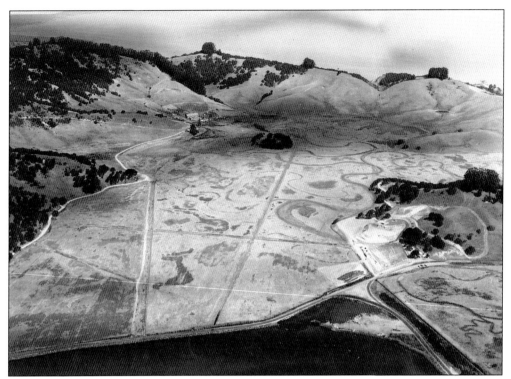

Peacock Gap was open land before it was developed in the 1960s. This image shows what the property looked like in the mid-1940s. The lagoon now sits in the foreground, and Point San Pedro Road skirts along the bottom of this photograph. Luxurious homes surround the Peacock Gap Golf Club. There are beautiful views of the bay from many homes.

Peacock Gap Golf Club has a golf course, designed by William F. Bell in 1958, as well as a clubhouse that includes a swimming pool and spa and fitness club. In 1964, Peacock Gap hosted the Marin Invitational Tournament of Stars, which featured such big names as Bing Crosby, Bob Hope, Kirk Douglas, and Dean Martin.

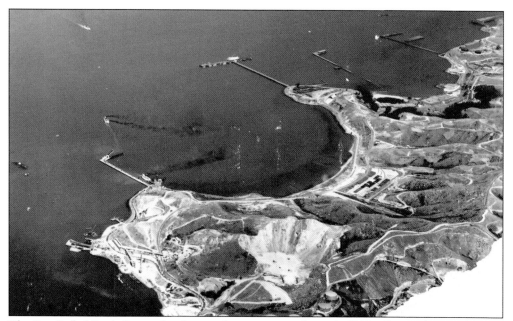

The San Rafael Rock Quarry has been in business since the early 1880s. Currently owned by the Dutra family, the quarry has been a source of complaints by nearby residents because of noise, truck traffic, and dust. The quarry owners have worked with the community to mitigate some of these nuisances.

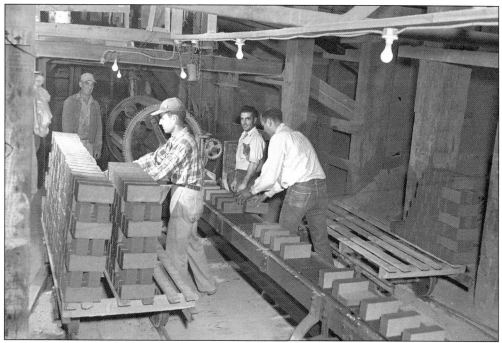

In 1859, John A. McNear and George W. McNear bought 700 acres on Point San Pedro east of San Rafael for $35,000. In 1947, the brickyard of the McNear Brick Company was leased to L.P. McNear. In this photograph, workers select bricks from a conveyor belt, discarding the imperfect ones.

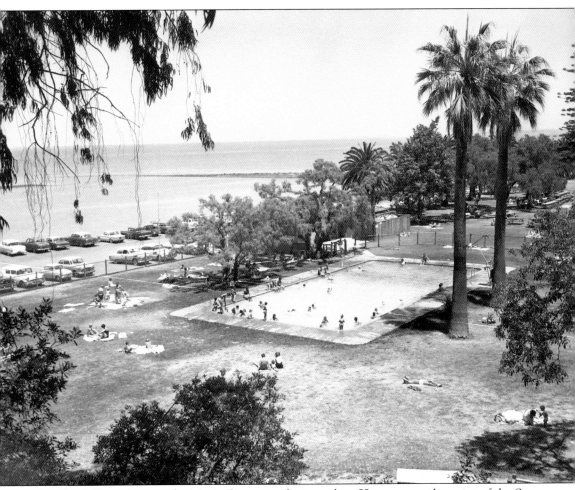

McNear's Beach is a popular Marin County park situated on 55 acres near the point of the San Pedro Peninsula. It was purchased from private ownership in May 1970. It is named for John McNear, who originally purchased the land with his brother George W. McNear in 1859 and took over the nearby brick-making operation. The park fronts San Pablo Bay and provides picnic tables, a swimming pool, tennis courts, and a fishing pier. The pier is one of the more popular piers in San Rafael, and anglers are often found fishing for sturgeon, bass, perch, halibut, and even crab. Fishing success is heavily dependent on the tides because the pier is so close to the peninsula's point. This photograph, taken in 1961, shows San Pablo Bay in the background as families enjoy the McNear's Beach swimming pool.

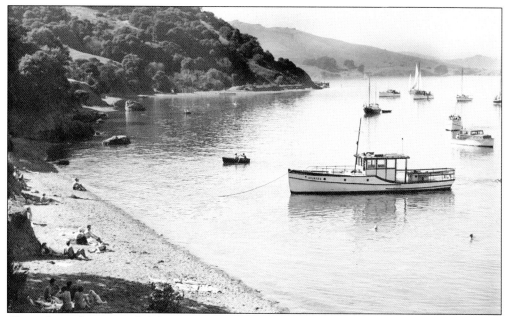

China Camp became a California State Park in 1978. The origins of the site date back to the 1880s when it was a Chinese shrimp-fishing camp. When this photograph was taken in the 1940s, only the Quan family of the original occupants remained. They operated a small resort, which sold shrimp and other snacks. They rented fishing boats and provided the small beach for wading and swimming in San Pablo Bay.

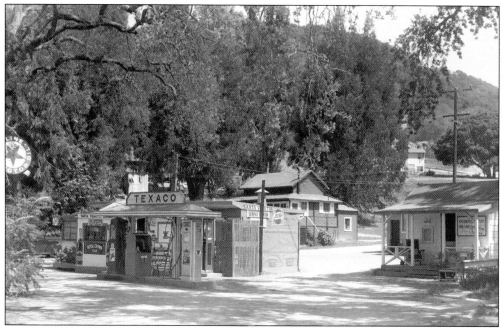

Santa Venetia was an undeveloped rural area in the 1940s when this photograph was taken. The only commercial ventures were the Texaco gas station and the small general store owned by Ruth and John Tweedie. This rustic remainder of a simpler time closed in 1968. Posted on the front of the building to the right is a sign advertising Venetia acreage lots for sale.

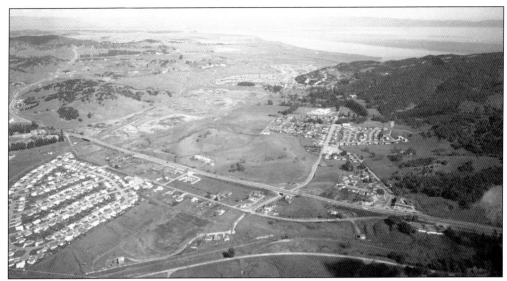

Santa Venetia housing development began in 1952 when J.D. O'Connor Construction Company started building what was known as Gallinas Village. The first homes were built on Vendola, Gallerita, and Adrian Streets. The homes sold for $14,000. In the center of this image toward the top is Santa Margarita Island, which by the end of the century was almost entirely surrounded by homes.

Santa Margarita Island, an open-space preserve, lies in the South Fork of Gallinas Creek. Crumbling retaining walls remain from Mabry McMahan's dream of an island resort with Venetian canals. Modern developers attempted to build condominiums on the island, but neighbors squashed all these ideas. In 1978, it was purchased with funds collected from the neighbors and Marin County. (Photograph by John Starkweather.)

Three

EXPANDING INTO

THE NORTH

TERRA LINDA AND MARINWOOD

After World War II, San Rafael was ready to expand. Luckily, the city was surrounded by rolling hills and scattered ranches. Manuel T. Freitas Ranch, just north of downtown and west of Highway 101, was renamed Terra Linda and in 1953 was sold to developers who built homes for the new Marin families. Marinwood, just north of Terra Linda, originally was the Miller Ranch and was developed by Gerald Hoyt in 1955. Both communities are populated with Joseph Eichler's unique style of homes. Known as Eichlers, the homes feature an indoor-outdoor lifestyle that perfectly suits San Rafael's fine climate. Northgate Shopping Center was built in 1964 on 70 acres in Terra Linda. With many shops, businesses, services, and acres of free parking, the Northgate Shopping Center became the main retail area in San Rafael. Northgate Industrial Park on the east side of Highway 101 began development in 1960. The industrial park offered lots for light industry and businesses with easy highway access.

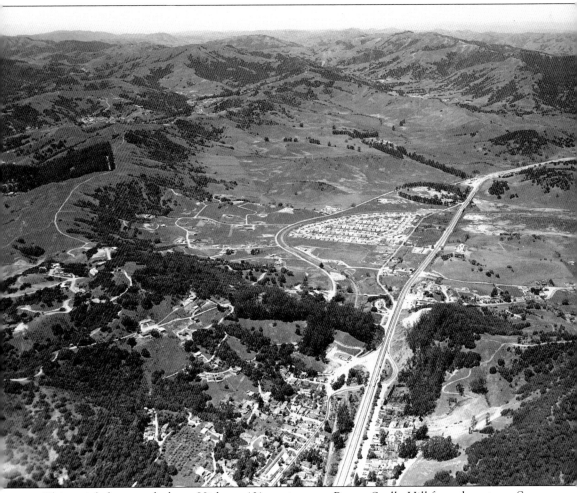

This aerial photograph shows Highway 101 passing over Puerto Suello Hill from downtown San Rafael in 1955. Heading north up the highway is a new housing development, which is bounded by Los Ranchitos Road and the Northwestern Pacific Railroad tracks on one side and Highway 101 on the other. The Marin County Civic Center is not yet built, and the Scettrini barns are still standing. Farther north is Mount Olivet Cemetery encircled by trees on the west side of Highway 101. Mount Olivet Cemetery was a gift from John and Maria Lucas on March 6, 1880. Just as the highway bends right, a long line of eucalyptus trees marks the entrance to the Freitas Ranch house. Manuel T. Freitas, a Portuguese immigrant, bought 1,200 acres from the Lucases in 1896. When M.T. Freitas died in 1923, his children inherited the ranch. Nearly everything in this photograph was once owned by the John Lucas. He inherited it from his uncle Timothy Murphy. Just a few years after this photograph was taken, the valley changed forever.

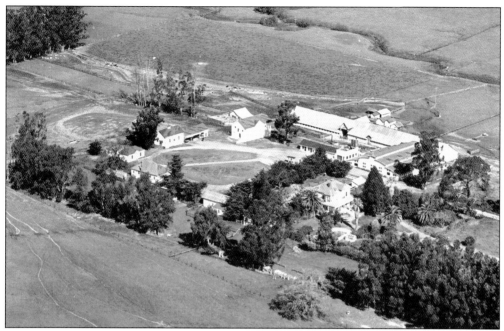

The Freitas Ranch was kept in the family until 1953 when 400 acres were sold to the Terra Linda Corporation, which received approval to build 5,700 homes. The old homestead was donated to the archbishop of San Francisco and is the site of St. Isabella's Church and School plus the Maria B. Freitas Senior Housing complex.

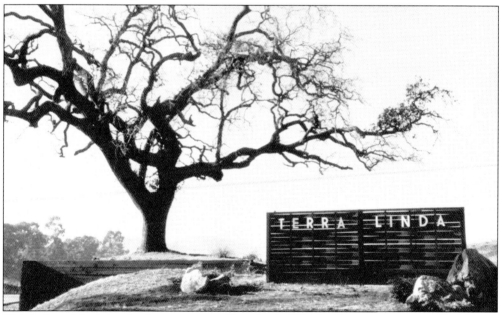

This is the original sign for the entrance to Terra Linda. The development was named by Manuel T. Freitas's daughter Rose and means "beautiful land" in Portuguese. The first residents drove in on one lane and out on one lane on Manuel T. Freitas Parkway, which ran alongside the drainage ditch. In the beginning, there were no street signs, fences, lawns, or trees in the development. (Photograph by John Starkweather.)

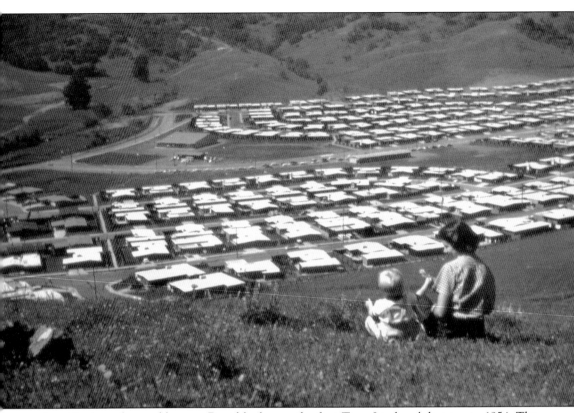

Jean Starkweather and her son David look over the first Terra Linda subdivision in 1954. The white-roofed houses in the valley are Eichlers designed by Joseph Eichler, who planned his contemporary modern homes to blend the outdoors with the indoors. In the distance is Scotty's Market and a gas station. To the right is the Terra Linda Recreation Center. In the next few years, a shopping center will spring up around Scotty's Market, a fire department will move in across the street, and the recreation center will add a swimming pool. Jean Starkweather is a noted environmental activist in the county, and her husband, John, sat on the San Rafael City Planning Commission for 12 years, among other things. Some of Jean's efforts to preserve open space resulted in the preservation of the land she and her son share in the image. (Photograph by John Starkweather.)

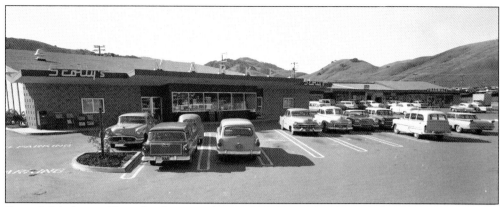

Scotty's Market in Terra Linda opened in 1957. It was a family-owned store that served the neighborhood with quality groceries, a deli, and a popcorn machine. The business was started by the Bianchini family and is now owned by Dale Lee. Popcorn is still served in the market, much to the delight of neighborhood children.

In 1957, the Terra Linda Community Services District was formed. Voters approved a bond issue in 1961. Ground was broken for the Terra Linda Community Recreation Center on January 28, 1962. The recreation center and pool have been remodeled several times over the years. They provide a popular place for families to play and swim.

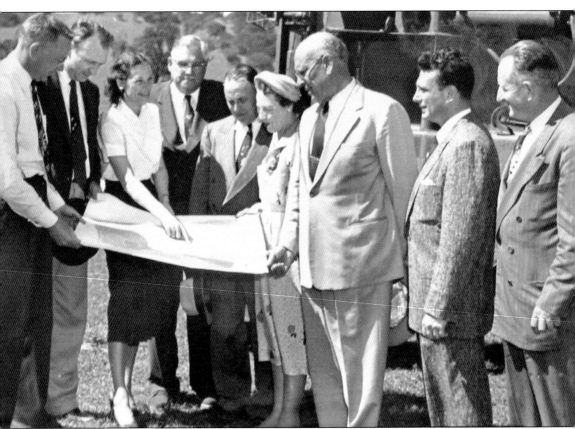

In June 1955, developer Gerald Hoyt, the Marin County Board of Supervisors, and planners look over the proposed new Marinwood development. This neighborhood begins at Lucas Valley Road and extends north to the end of Las Gallinas Avenue. The Marinwood Community Services District was created on February 17, 1960. In 1950, Marin's population was 85,619, but by 1960, just 10 years later, it had jumped to 145,545. In 1974, the local newspapers ran an advertisement for homes in Marinwood. The single-family homes were selling for $47,950. This price included garage-door openers, log lighters, and "careful planning." The individuals in the photograph are, from left to right, R.B. Hammond, Marvin Brigham, Mary Summers, William Fusselman, William Gnoss, Vera Schultz, Walter Castro, G.G. Hoyt, and James Marshall. (Courtesy of the San Francisco History Center, San Francisco Public Library.)

Joseph Eichler built his distinctive homes all over the Bay Area. His philosophy was to provide good architecture to middle America. There are Eichler homes in both Terra Linda and Marinwood. Eichler followed some of the precepts of Frank Lloyd Wright. Eichler built homes with little distinction between the outside and inside. The homes have a low profile with a large amount of glass and are stripped of all unnecessary decoration.

Northgate Mall was constructed in 1964. The Emporium Department Store was one of the anchor stores. Here, the E is hung on their building. The many stores and services drew customers from all over Marin County. However, it was the acres of free parking that made the mall so successful.

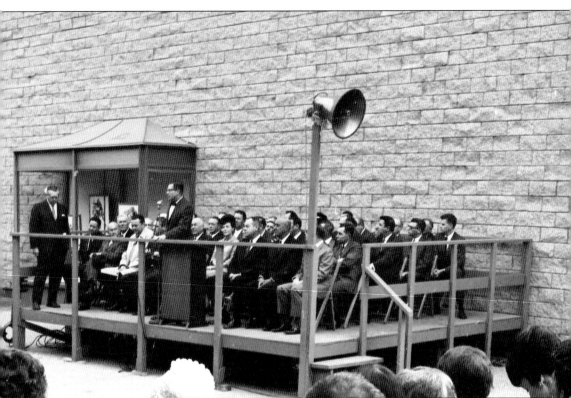

The opening ceremonies for Northgate Fashion Mall were held on March 11, 1965. They are attended by city dignitaries and members of the Freitas family. The Freitases owned the land for many decades before selling it to developers. In this image, ceremony participants are seated on a platform near the base of the new Emporium building. Just out of frame hangs Emporium's giant, cursive E above the platform. The shopping center was the largest commercial venture in San Rafael history and changed the whole retail shopping patterns for Marin County. Delighted by the new mall and the free parking, shoppers bypassed downtown San Rafael and spent their money at this new Northgate Fashion Mall. Downtown San Rafael retail businesses suffered from competition. Emporium and Sears became the two anchors, and many new businesses moved into the mall.

Originally, Northgate Fashion Mall was an open-air shopping center. The walkways were bordered by flowers and plants designed by Laurence Halprin; additionally, there were reflecting pools and a cascading fountain. Halprin, an influential American landscape architect and designer, also designed Levi Plaza and Ghirardelli Square in San Francisco and was the master landscape planner for Sea Ranch in Sonoma.

In 1986, work began to enclose the Northgate Fashion Mall, now renamed the Northgate Mall, making shopping more attractive in all seasons. More stores opened in the mall, which featured overhead skylights, parquet floors, and palm trees. The new mall reopened in October 1987 and was the only enclosed mall in the county. By the end of the 20th century, plans were in place to remodel the mall again.

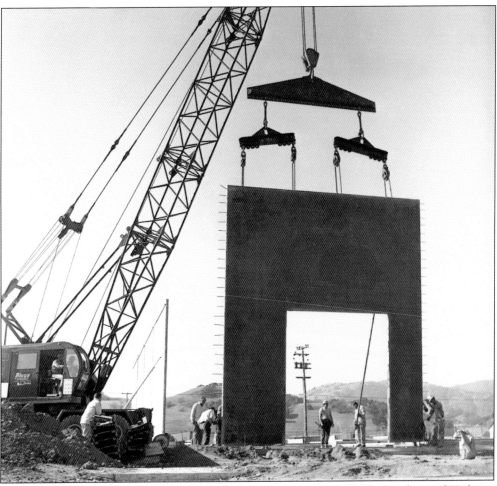

Northgate Industrial Park opened in 1960 on 140 acres north of San Rafael and east of Highway 101. The industrial center was designed for light industry and businesses that needed more space than was available in the city of San Rafael. The proximity to the highway and the railroad made it particularly attractive to manufacturing enterprises.

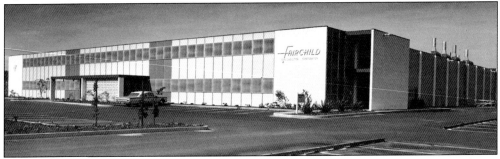

When Fairchild Semiconductor's plant opened in 1960, it was one of the first tenants of Northgate Industrial Park. The plant was welcomed because it appeared to be an example of clean industry. The plant closed in 1986, and it was later discovered that the site was contaminated with chemical solvents used to clean the semiconductors. It took many years before the site was declared safe for reuse.

Four

FROM HERE TO THERE
AUTOMOBILES CHANGE CITY LIFE

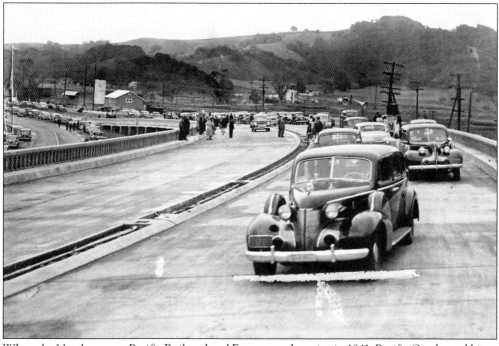

When the Northwestern Pacific Railroad and Ferry ceased service in 1941, Pacific Greyhound Lines bus service began transporting commuters across the Golden Gate Bridge. In 1972, the Golden Gate Bridge District took over the Greyhound's routes, and Marin County Transit District began local bus service in 1971. Although a huge effort has been made to reduce traffic, over 90 percent of all trips in Marin are by automobile. Bus service has been upgraded and high occupancy vehicle (HOV) lanes added to encourage carpooling, but most cars on Highway 101 still have a single occupant. The San Quentin ferry was replaced by the Richmond–San Rafael Bridge in 1956. The ferry strikes of 1947 and 1949 gave impetus to building the bridge. The bridge is officially named the John F. McCarthy Memorial Bridge after the state senator who died in 1981. San Rafael has been home to three airports: the San Francisco Bay Airport, the Santa Venetia Airport, and the San Rafael Airport. Only San Rafael Airport is still operating. (Courtesy of the San Francisco History Center, San Francisco Public Library.)

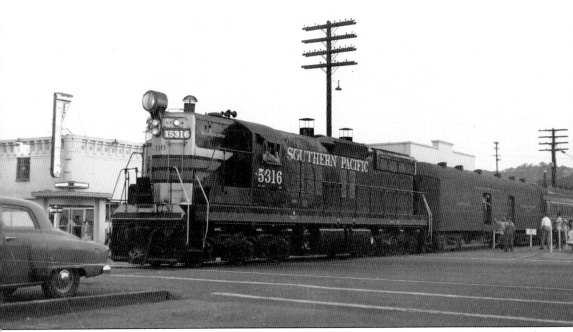

Even though the commuter train stopped running in 1941, the Northwestern Pacific Railroad (owned by Southern Pacific) ran a passenger train three times a week from San Rafael to Eureka. On November 9, 1958, the San Rafael-to-Eureka train made its last run. By 1992, there was no longer freight service south of Ignacio. The last freight train ran in Marin County in 2001.

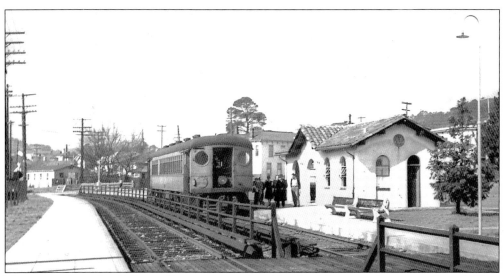

The original wooden B Street Station was replaced by this Mission-style station about 1928 as part of a modernization program that updated several older stations. It originally sat behind the Flat Iron Building on Second Street near B Street but was moved to a private right-of-way in 1930. Currently, it sits on the 700 block of A Street. Over the years, it has served several small businesses.

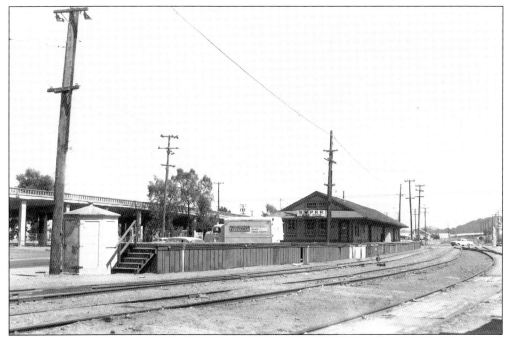

Located south of the passenger station on Irwin Street, San Rafael Freight Station was a standard Southern Pacific wooden design with a freight office and warehouse. Historian and retired railroad employee Fred Codoni noted that as many as 100 freight cars, serving shippers and receivers in San Rafael and as far south as Greenbrae, Larkspur, and Corte Madera, were handled in a day in the 1950s.

After the Northwestern Pacific Railroad ceased commuter service in 1941, Pacific Greyhound Lines moved in. The buses used the office adjacent to the railroad tracks, pictured here, so commuters did not need to alter their commute patterns by much. The new bus service transported workers to San Francisco over the Golden Gate Bridge, which was just a few years old in 1941.

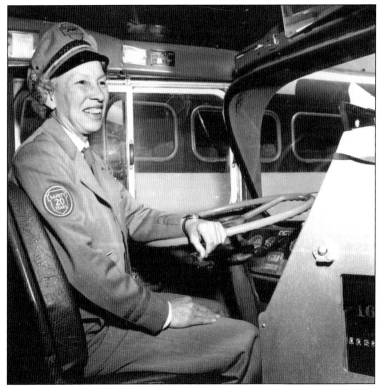

Jerrine Doty, seen here in 1965, had a 20-year safe-driving award bestowed on her by Pacific Greyhound Lines for accident-free driving in the heavy traffic of the Marin-to-San Francisco commute. Reliable drivers like Doty gave commuters an easy, safe commute.

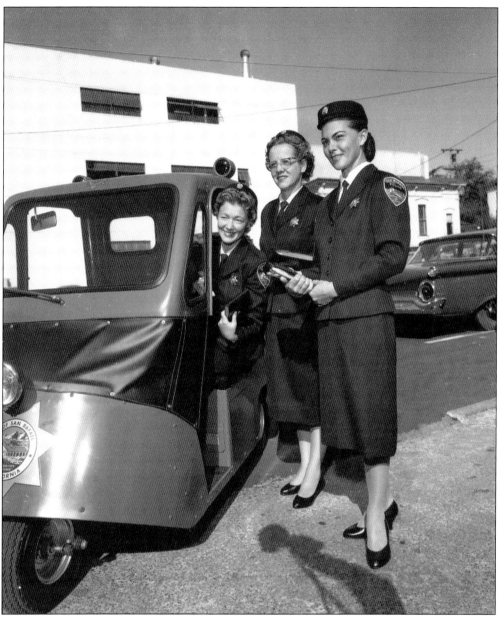

In the 1950s, the city of San Rafael installed parking meters downtown. Soon on their heels came the meter maids. Pictured here are the first three meter maids hired for the city of San Rafael. They were hired in September 1959, sported blue uniforms, and drove blue scooters. Their job description was to ticket cars that stayed too long in metered and unmetered limited parking zones. This image was featured on the front page of the *Independent Journal* on September 30, 1959. The women are described as "three young married women . . . from left, they are Mrs. Bert Anderson of Santa Venetia, Mrs. Willard Weldon of Tiburon and Mrs. Pat Prudhomme of Mill Valley." Times have changed, and by the end of the 20th century, meter maids shed their archaic titles and were called parking enforcement officers or parking attendants.

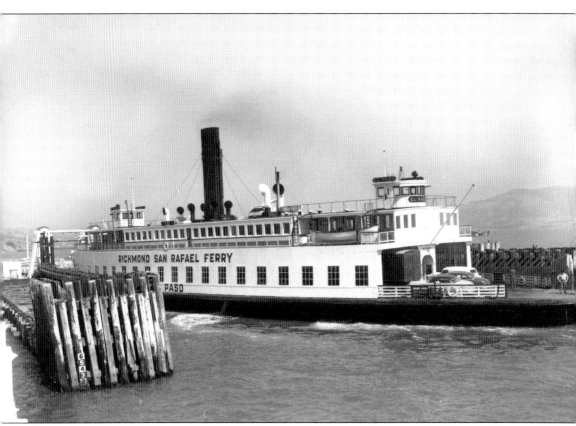

The San Rafael–Richmond Ferry carried cars and passengers between San Quentin Point in Marin County and Richmond in the East Bay. The ferry started service in 1915 and ran until its last crossing on August 31, 1956. The *El Paso*, seen here, was a 240-feet, steel-hulled, double-ended ferry. Because the ferry was double ended it did not ever need to turn around; it simply pulled into the dock, loaded cars and passengers, then pulled out "backwards" and headed to the other side of San Pablo Bay. On the highest level of this ferry, two captain's cabins are visible; the captain used one when heading west and the other when heading east. This was also advantageous for cars, as they could pull straight through the ferry without ever needing to make a U-turn.

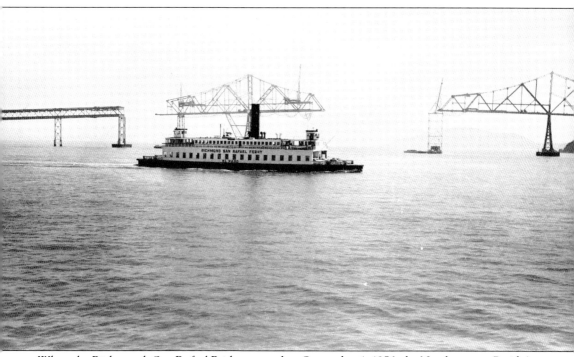

When the Richmond–San Rafael Bridge opened on September 1, 1956, the Northwestern Pacific's ferry service ended. Many missed the 20-minute ferry crossing, but others were glad to not wait in line and preferred to take the new bridge. Because of cost concerns, the bridge, known as "Old Swayback" or the camelback bridge, has an unusual and not altogether pleasing design. Its cantilever and truss design is five and a half miles long and has two lanes going east on its upper deck and two lanes going west on its lower deck. A third lane on each deck is reserved for maintenance and emergencies. Connecting Marin and Contra Costa Counties, it was one of the longest bridges in the world at the time it was built. It arches over two principal ship channels, allowing container ships and ships bound for the oil refineries to pass safely underneath.

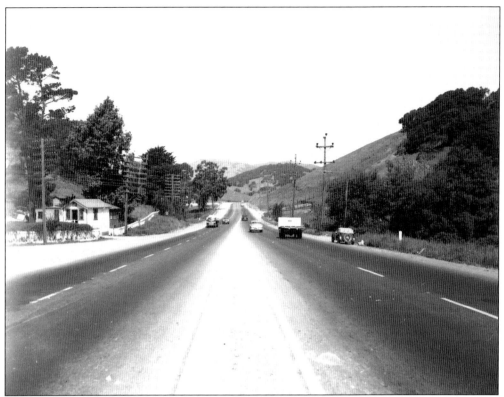

In 1949, the highway known as 101 was a two-lane road that wandered through the streets of San Rafael until it reached Puerto Suello Hill and passed the entrance to Mount Olivet Cemetery, shown on the left. At this time, neither the middle barrier nor the overpasses existed. Drivers waited in the fast lane until they could make a left turn across oncoming traffic.

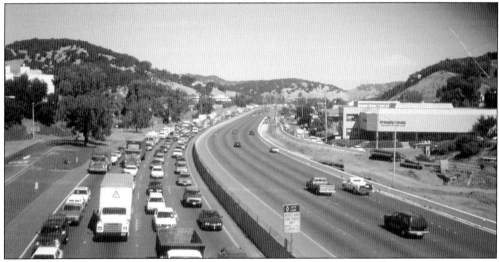

This photograph taken in 1985 shows the same stretch of Highway 101 after it was expanded to nine lanes across: four southbound and five northbound. As the freeway was widened, increased traffic filled the lanes to capacity. This image shows the drivers commuting south to Central San Rafael, southern Marin cities, and San Francisco.

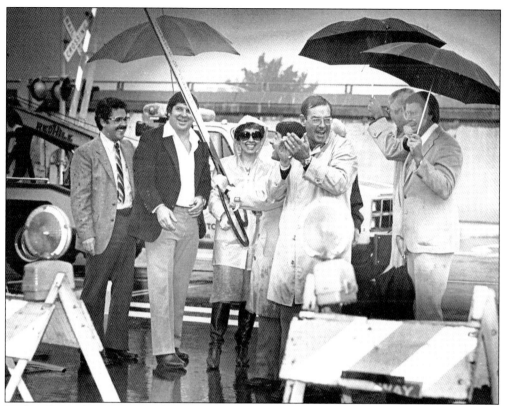

In this December 19, 1981, photograph, San Rafael mayor Larry Mulryan is seen cutting a ceremonial ribbon while Scott Deming applauds and San Rafael chamber officials look on. The ribbon cutting opened a connector road between West Francisco Boulevard and San Rafael's downtown business district, ending 11 years of merchant lobbying. The new roadway eliminated a tedious bottleneck and allowed drivers easier access between points.

In 1973, an oil embargo was imposed on the United States by the OPEC nations because of America's support of Israel. In an effort to conserve gasoline, Pres. Richard Nixon introduced a ban on selling gasoline on Sunday. Gasoline was approximately 30¢ a gallon but quickly shot up to $1.20 a gallon. Even those who would pay that price had to wait in line to fill their gas tanks.

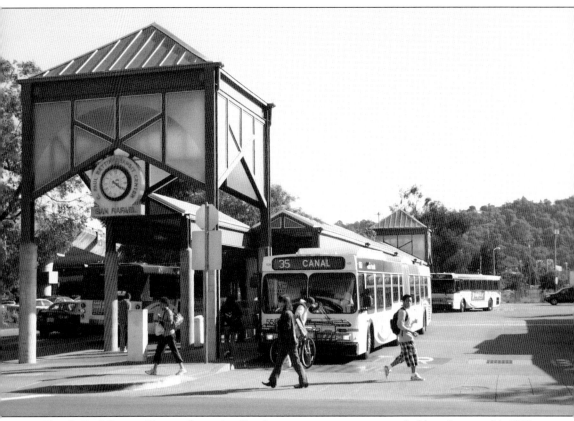

The C. Paul Bettini Transit Center's official opening ceremonies were held on January 24, 1992, although buses started rolling through 12 days earlier on January 12. The transit center is named after the former mayor of San Rafael who served the city from 1965 to 1979. Bettini also served on the city's board of education and was a member of the Golden Gate Bridge District Board. The transit center is located on a block bounded by Second Street on the south, Third Street on the north, Hetherton Street on the east, and Tamalpais Avenue on the west. As one of the Golden Gate Transit's busiest hubs, the transit center links pedestrians with Golden Gate Bus Transit, paratransit providers, airport transportation, and taxis. Robin Chiang & Co. (RCCo), an architecture and planning firm from San Francisco, designed the transit center with an eye toward modernity and design.

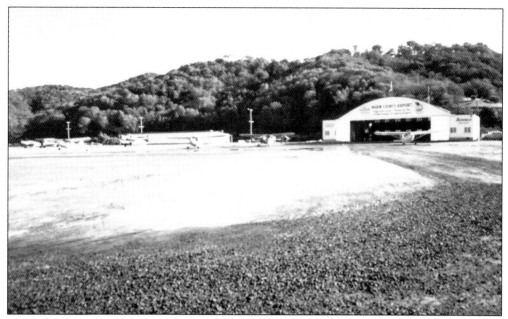

Located in Santa Venetia on Adrian Way and Vendola Drive, San Rafael Airport operated as a private airport from the late 1920s to the 1950s. Nearby development ended the operation of the airport. The hills rise up behind the hanger in this 1940s image; by the end of the 20th century, these became part of the San Pedro Mountain Open Space Preserve.

The newly christened San Rafael Airport has been open off and on since 1928 and is seen here in 1951. The airport has been known by several names, including the Smith Ranch Airport and Marin Ranch Airport. Still open at the end of the 20th century, it served private planes by providing hangars and a 2,000-foot paved runway.

Few remember the San Francisco Bay Airport. It was a private airport in east San Rafael on Railroad Avenue (now known as Bellam Boulevard). It began operation in approximately 1947 as a private airport managed by Jimmy Rusch. At that time, it was just a dirt runway. The owners coated the runway with crankcase oil to keep down the dust. However, by the mid-1950s, development in the area made takeoffs and landings unsafe, and the airport shut down in 1959. The assignment sleeve of the four-inch-by-five-inch Kodak negative from the *Independent Journal* states, "5/59 San Rafael closing of San Rafael Airport," followed by the parenthetical comment, "Who's doing all the work?"

Five

MEETING THE NEEDS OF SAN RAFAEL FAMILIES

SCHOOLS AND CHURCHES

In 1850, San Rafael's population was 323, but by 1920, it had grown to 5,512. The schools grew accordingly, especially between 1950 and 1970 when the city saw a building boom. The elementary schools include Bahia Vista, Coleman, Glenwood, Laurel Dell, San Pedro, Sun Valley, Short, Dixie, Vallecito, and Mary E. Silveira. Middle schools are Davidson and Miller Creek. After graduating, students from Davidson, Miller Creek, and Venetia Valley attend either San Rafael or Terra Linda High Schools. San Rafael is also home to several excellent private schools, ranging from military, religious, and secular. San Rafael is also home to many churches from many theological beliefs. Some churches have a long history in San Rafael, dating back to the Victorian age. Others have grown up with the baby boomers and are still active.

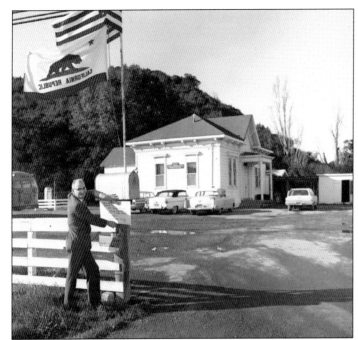

The Dixie Schoolhouse was built in 1864 and used by the Dixie District until 1954 when new schools were built to accommodate San Rafael's postwar population explosion. On June 10, 1971, the schoolhouse was moved a half mile to its present location at 2245 Las Gallinas Road. It is a fine example of a mid-Victorian schoolhouse and is currently used for educational purposes and community events.

In 1924, the original E Street School was built, but after the 1933 Long Beach earthquake, the building was inspected and ruled unsafe. It was demolished and replaced with a new school that opened in 1936. In 1963, the San Rafael District began selling off the property and buildings. In 1964, E Street students moved into the new Glenwood School, and the E Street School was closed.

Glenwood Elementary is a school for kindergarten to fifth grade that opened in 1964 at 25 Castlewood Drive, which is located east of Central San Rafael. The school serves a community composed primarily of single-family homes in east San Rafael and includes overflow students and intra-district transfer students from other areas of the community. Glenwood Elementary is a California Distinguished School and a National Blue Ribbon School.

Located at 75 Happy Lane, Sun Valley Elementary School was built in 1951. In 1964, a project totaling $123,700 was undertaken to add three new classrooms and a school library to accommodate the ever-increasing enrollment. A construction worker is seen here helping build the modern school.

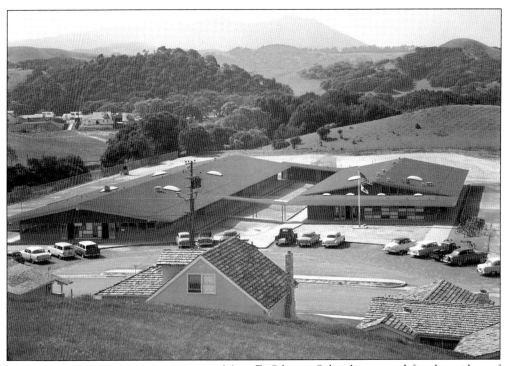

Mary E. Silveira School is named for the widow of Anthony Silveira, owner of the Silveira Ranch. The ranch included dairy pastureland, vineyards, and the Miller Mansion. The school stands where the Miller Ranch vineyards grew. In 1953, the newly built elementary school in Marinwood was dedicated to and named in Mary's honor.

Mary E. Silveira, widowed at 37, carried on with the responsibilities of the family dairy business and service to the Dixie School District. Silveira served as a trustee from 1938 to 1956—a time of rapid growth in the district. She died in 1982. Shortly after her death, the school was closed because of declining enrollment. With many new families moving into the district, the school reopened in 1991.

Davidson Middle School was built in 1953 and is named for James B. Davidson, who served as superintendent of schools in San Rafael from 1903 to 1935. In 1959, the Santa Venetia School on North San Pedro Road was converted to a middle school. In 1982, as the city's demographics changed, there was no longer a need for two middle schools, so Davidson and Santa Venetia were combined. Controversy surrounded the renaming of the newly combined school. It was suggested to call the school San Rafael Middle School but there was great public outcry to retain the name of Davidson. Because of urging from the public, the school board retained the name of Davidson Middle School. Santa Venetia School was reopened in the 1990s and renamed Gallinas K–8, then later renamed Venetia Valley K–8. It is the only school in the San Rafael School District that serves students in kindergarten through eighth grade.

Terra Linda High School opened on September 6, 1960, even though construction was still under way. The administrative offices, 11 classrooms, and the cafeteria were complete. The gymnasium opened the following week. Construction continued on the music buildings and shops. The school was built to accommodate 700 students at a cost of $1,245,000. The first principal was Webster D. Wilson, who was the director of instruction at San Rafael High School.

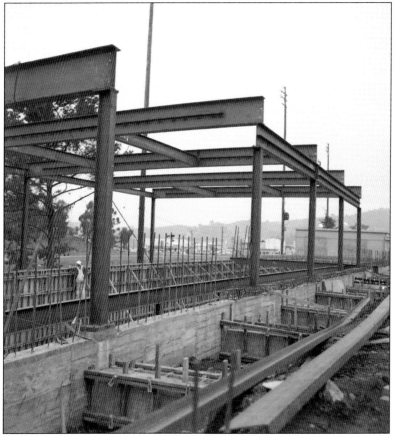

San Rafael High School's cornerstone was laid on December 13, 1924, and it opened in the fall of 1925. By 1954, San Rafael High School, which was built for 750 students, housed 833 students. In 1964, the library and 17 classrooms were razed to make way for a new library and 37 classrooms. The current school has several main buildings, occupies 33 acres, and serves approximately 1,000 students.

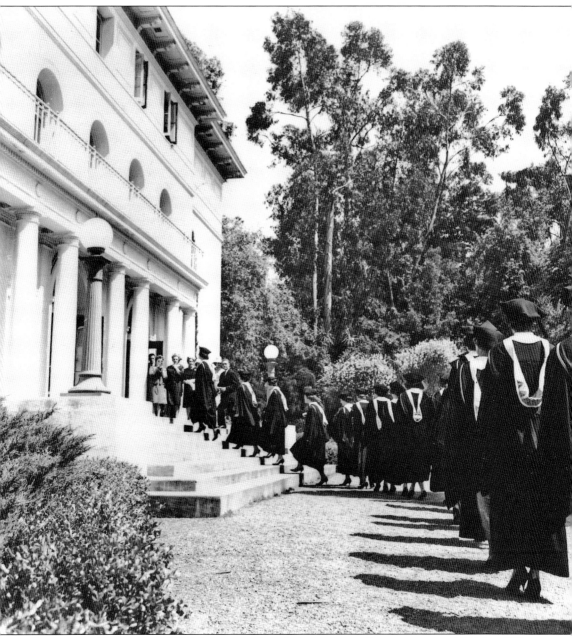

Dominican University of California was founded as a women's university in 1890. In 1950, Dominican opened its graduate program to men, and it became fully coeducational in 1971. Dominican is a Catholic-heritage university, not a Catholic university. The university is no longer administered by the Dominican Sisters, although some sisters sit on the board of trustees.

San Rafael Military Academy was established in 1925 when A.L. Stewart bought the Mount Tamalpais Military Academy. In 1945, an organization made up of parents of cadets took control of the academy. In 1959, it was sold to the Episcopal Diocese of California. Financial pressures in 1971 caused the school to close. Marin Academy, a private college preparatory high school, took over the school, opening its doors in 1972.

St. Vincent Home for Boys started in 1853 and functioned as an orphanage for many years. There is a large courtyard, many gardens, and a grotto in honor of Our Lady of Lourdes. The chapel itself is in traditional, pre-Vatican II design. The altar and the sanctuary are Gothic Revival, and the ceiling is a faded but lovely Arts and Crafts design. Today, St. Vincent is the largest provider of youth residential treatment services in Northern California. The Therapeutic Equestrian Program is an effective tool that helps boys who have been so severely traumatized they find it almost impossible to form emotional bonds with anyone literally take back control of the reins of their lives.

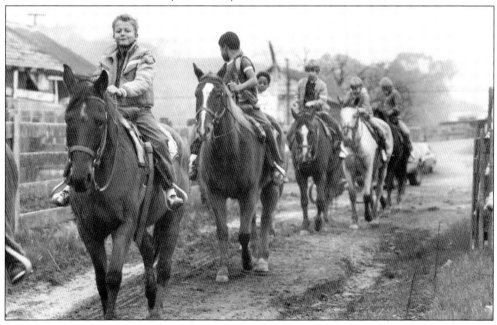

The Marin Jewish Community Center's ground breaking was June 12, 1988. The complex includes a community center, Brandeis Hillel Day School, and Congregation Rodef Sholom. During the 1940s, the Marin Jewish community would gather at houses in the community for Shabbat services. In 1948, the Marin Jewish Community Center (JCC) opened at 1618 Mission Avenue.

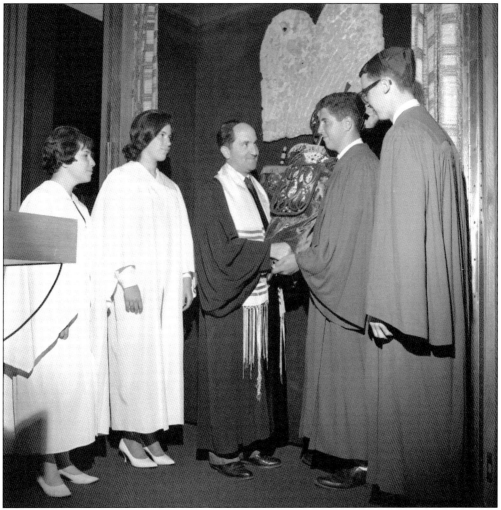

The JCC held services each week and out of these services grew Congregation Rodef Sholom, founded in 1956. By 1959, the Jewish population of Marin County was 2,700 with 225 families belonging to Rodef Sholom and over 300 children attending its religious school. On June 4, 1961, the community held a ground-breaking ceremony for its new synagogue, which was dedicated on May 4, 1962. The new building featured a stained-glass window in the hexagonal high ceiling that was donated by the Koch family, stained-glass windows at the front entrance donated by Rose Albert, and an organ from the Men's Club.

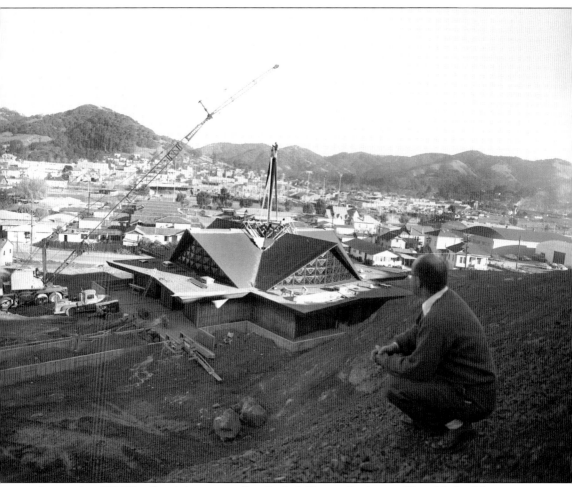

Located at 333 Woodland Avenue in San Rafael, Trinity Lutheran Church's final home was purchased in 1958, and construction was finished in 1961. Because Trinity Church occupied the entire block, the city allowed it to choose its own address, hence the Trinitarian reference in the numbers 333. Trinity Church has a preschool and kindergarten and provides Bible studies. Trinity Church also undertakes outreach to care for community members. They support Mill Street Shelter along with participating in Angel Tree Ministry and supporting the Pregnancy Resource Center.

The Church of St. Isabella was built on property donated by the Freitas family in Terra Linda. Its first pastor, the Reverend Edward Dingberg, was appointed in 1961. Reverend Dingberg had previously been the Catholic chaplain at San Quentin. The parish operates a school educating students in kindergarten through eighth grade in academics and the Catholic faith.

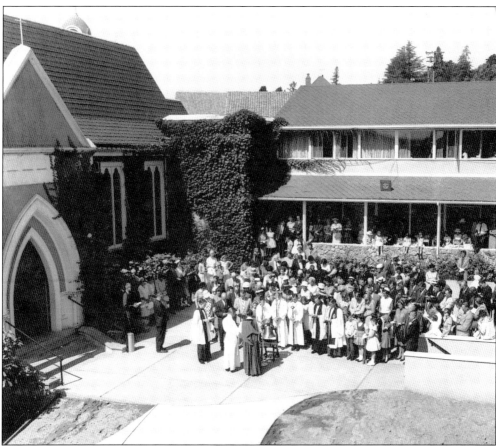

St. Paul's Church at 1123 Court Street was built in 1869 and was the home parish for the Fairfax, Taliaferro, and Boyd families. In 1924, it was moved from E Street, and the old guild hall was moved to make way for the new one in 1958. The dedication of the new education building on September 8, 1963, is seen here. (Courtesy of St. Paul's Episcopal Church.)

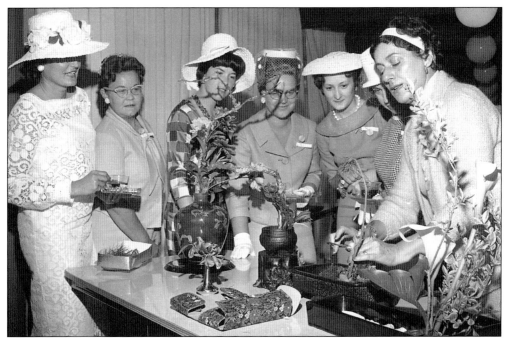

Aldersgate United Methodist Church was originally located at 220 Nova Albion Way. In 1980, they exchanged that property with Kaiser Permanente for property at 1 Wellbrock Heights. The new church was dedicated on December 18, 1982. In this photograph from the 1964 *Independent Journal*, women from the church gather for afternoon tea. The article identifies the ladies as, from left to right, "Mesdames Ron B. Simpkins, C. Edward Jacobs, Paul G. Schurman, W.W. Dunlavy, Vernon G. Swim, Robert J. Guthrie and Ernest Stewart."

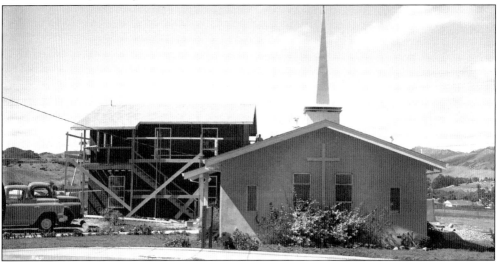

Valley Baptist Church was founded in 1950 when five families began meeting in a San Rafael home. After a short time, the church moved to the Bret Harte area. Eventually, the church moved to its current location on North San Pedro Road. In 1982, a new sanctuary was built, and a gymnasium was added in 2005. Stan Tilley served as founding pastor. He was followed in the late 1950s by Stanley Walsh. Warren Conrad was senior pastor from 1963 to 1993, and Chris Losey has served since 1994. Through its history, the church has emphasized world missions and evangelism.

Six

DISASTER STRIKES

FIRES, FLOODS, AND DROUGHTS

Fires, floods, and droughts have plagued San Rafael since before meteorologists started recording them. Since 1940, the city has seen innumerable house fires and many other significant blazes. These fires changed the landscape of the city just as much as the floods and droughts did. Many of the fires in San Rafael were caused by old wooden buildings that had none of the modern fire-suppression systems. The San Rafael Fire Department responded to these fires, but they quickly grew out of control, often because of improperly stored flammable materials. Floods and droughts are all part of living in this area. In winter, the nearness of the Pacific Ocean brings heavy rains to the area, frequently resulting in floods. San Rafael counts on these winter rains to supply the reservoirs. Occasionally, like in 1976 and 1977, the winter rains do not come, and the area suffers from drought. In 1991, the drought was not as severe as in 1976–1977 but still required mandatory water rationing.

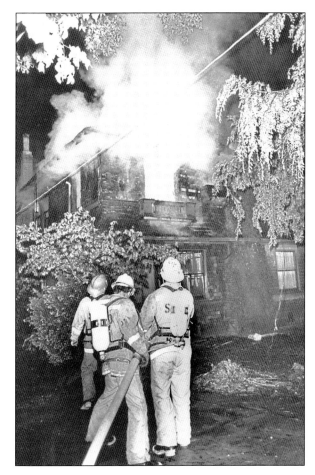

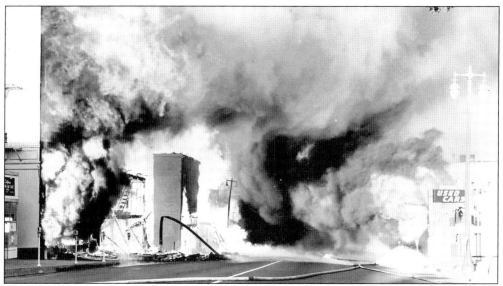

On July 29, 1957, one of the most devastating fires broke out in downtown San Rafael. The fire was reported at 7:45 p.m. by Ona Kromrel, who lived in an apartment at 1438 Fourth Street. Flames roared down Fourth Street between D and E Streets, quickly engulfing buildings as residents in a six-block area were evacuated. Help came from many sources, ranging from the San Francisco Fire Department to local teenage boys. Paint cans in Ayers Paint Shop fueled the fire as they exploded from the heat. The next morning, headlines in the *Independent Journal* read, "Lampposts Melt, Walls Fall As Flames Eat Way Down Fourth Street." Because of this fire, historic buildings end at D Street and mid-century structures continue to the west.

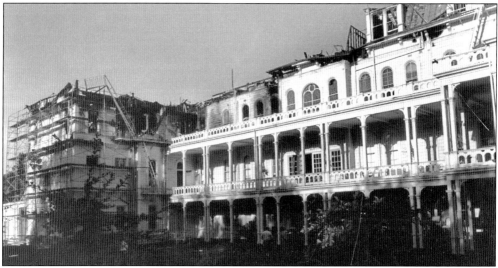

On July 12, 1990, a five-alarm fire destroyed Dominican Sister's 101-year-old convent house. The fire was caused by smoldering wood traced to a blowtorch used by a painting contractor hired to remove old paint during restoration efforts. Crews at first appeared to contain the fire, but it "flashed out" in the attic and more firefighters were called in. Old timbers, no sprinklers, and other fire-code deficiencies contributed to the destruction of the building. The fire was finally controlled four hours later but destroyed the convent's third and fourth floors. The building was deemed unsafe and was torn down.

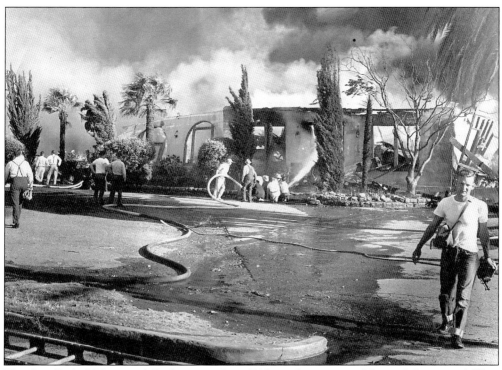

The San Rafael Municipal Baths opened in 1915 on the corner of Second Street and West Francisco Boulevard, later closing in the 1930s because of the Depression. In 1935, it became H.C. Little Burner Company, which built home oil burners. When the fire broke out June 4, 1949, the San Rafael Fire Department could not extinguish the flames because of the excessive chemicals; instead, they let it burn and saved nearby buildings.

A fire started inside Fourth Street's Mar Vista Motors on May 21, 1950, as crowds gathered in front to watch the fire department march in St. Raphael's Mission parade. The aggressive fire collapsed the roof, trapping firefighters Aubrey (Jack) E. Miller and William Bottini. Miller died instantly, and Bottini succumbed to his injuries 12 hours later. The firemen's deaths were the first in 75 years for the San Rafael Fire Department.

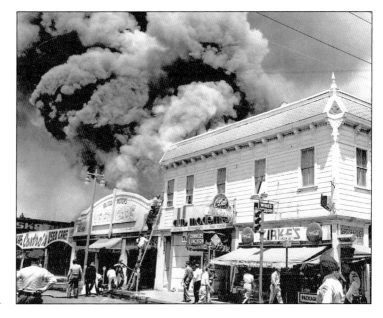

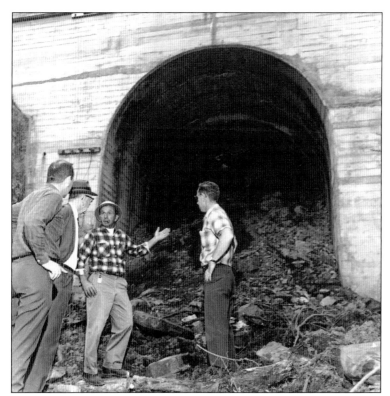

On July 20, 1961, the Northwestern Pacific wooden railroad tunnel (built in 1879 for the San Francisco & North Pacific Railroad) was destroyed. The blaze started when two boys threw homemade torches onto the creosoted timbers in the tunnel. When the tunnel collapsed, two apartment buildings and a fire truck fell in, killing firefighter Frank Kinsler. It took over six years to rebuild at a cost of $2.8 million.

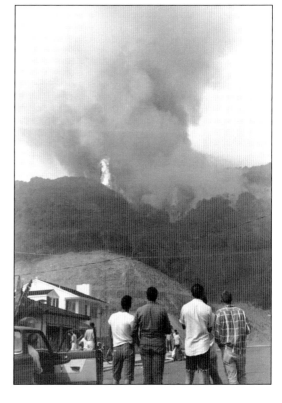

On August 19, 1954, the Black Canyon fire scorched 300 acres of San Rafael's hillside. As the temperature reached 96 degrees, a fire started above the Dominican neighborhood. Concern about the fire's proximity to the Nike missile site had Air Force, Army, the state forestry service, and the San Rafael Fire Department working with volunteers to fight the blaze. Fortunately, the homes and the Nike missile base were saved.

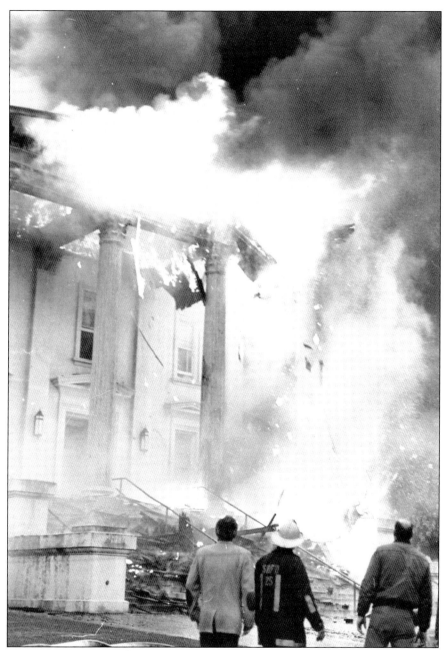

On May 26, 1971, an estimated crowd of 2,000 gathered as Marin County's 99-year-old courthouse burned to the ground. The courthouse, which was built in 1872, had nearly reached its centennial anniversary when the fire broke out. Just 16 hours after the San Rafael firefighters finished a routine inspection of the building, the fire was reported. The fire raged for hours as fire chief Vance Trivett and 40 firefighters battled the blaze. The fire was later discovered to be the work of an arsonist who had tried on at least one earlier occasion to set the courthouse ablaze. He never gave a reason for his actions. Fortunately, no one was injured in the fire, as the building had been vacant for two years since the completion of the county's new civic center, designed by Frank Lloyd Wright.

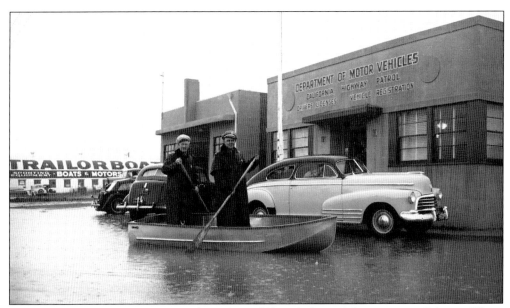

From January 14 to 17, 1950, six inches of rain fell, with four of those in just 48 hours. Water surrounded the local state automobile registration headquarters on Francisco Boulevard. People had to be carried across the "lake" by boot-wearing rescuers or faced walking the "plank," a temporary bridge from another building.

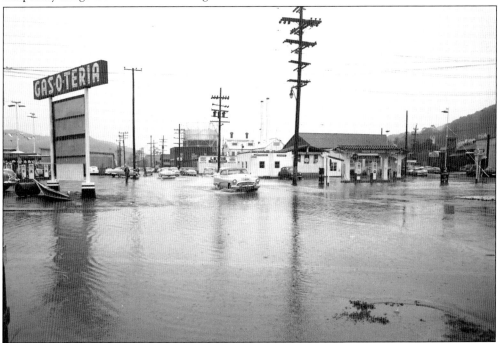

On December 19, 1955, after a weekend of heavy rain and gale-force winds, Lincoln Avenue from Francisco Boulevard to Third Street was closed, as was Second Street between A Street and Lincoln Avenue. Mahon Creek at Albert's Lane and Lindaro Street had overflowed its banks. Boy Scouts floated rowboats to help stranded holiday shoppers in downtown San Rafael. The rain continued until December 24, causing sporadic flooding.

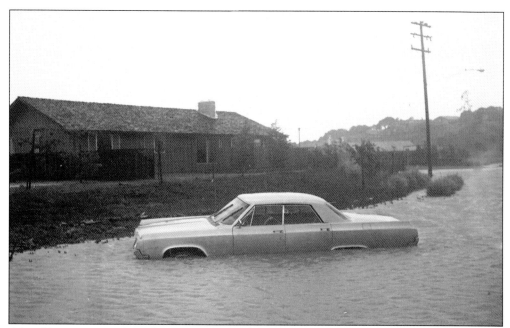

After 14 continuous days of rain, San Rafael had a New Year's Day respite only to have heavy rains return January 2–6, 1965. By then, the season rainfall total in San Rafael was over 27 inches. Point San Pedro Road was closed at the entrances to Peacock Gap, as the rain and water blown off the bay at high tide turned the street into a canal.

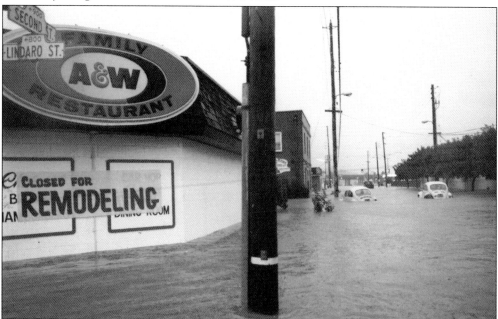

On January 4, 1982, a state of emergency was declared in San Rafael after 6.4 inches of rain fell in a 16-hour period. This combined with a high tide caused landslides, and 21 homes were destroyed. The hardest hit areas were Glenwood Drive, Mountain View Avenue, D Street, West Francisco Boulevard, and the area above Gerstle Park. Highways 101 and 37 and the Golden Gate Bridge were closed.

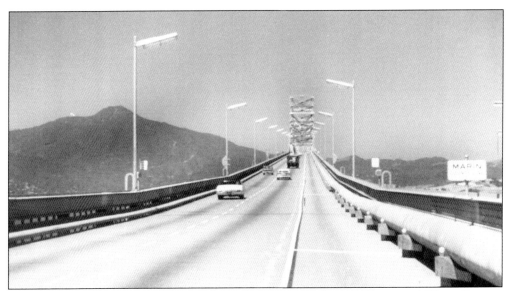

California's worst drought, from 1976 through 1977, pushed Marin Municipal Water District general manager J. Dietrich Stroeh and former county supervisor Arnold Baptiste to secure funds to bring water over the Richmond–San Rafael Bridge in a 24-inch-diameter pipe. The pipe, on the right of the photograph, transferred eight million gallons of water a day from the East Bay Municipal Utility District. A year later, the pipeline was removed. (Courtesy of the Marin Municipal Water District.)

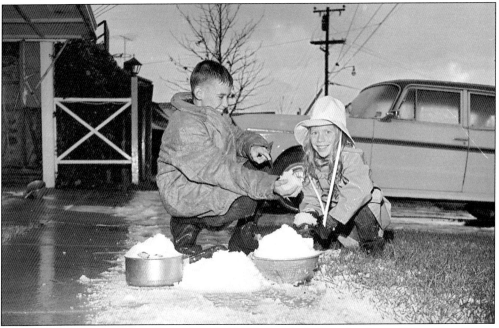

Unseasonably cold weather on December 28, 1964, led to the *Independent Journal*'s headline, "Snow falls on Mount Tam, thick hail pelts Marinwood." Appearing below the headline, this photograph shows James Haynes (age 12) and his sister Becky (age 8) taking advantage of the season's biggest storm. Telephone service was interrupted near Third and Irwin Streets downtown, but the Pacific Telephone and Telegraph Company was able to quickly repair the lines.

Seven

Frank Lloyd Wright Designs an Icon
Marin County Civic Center

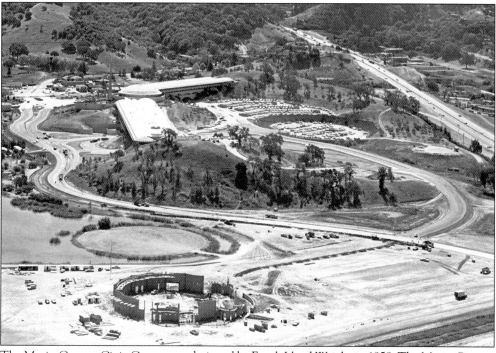

The Marin County Civic Center was designed by Frank Lloyd Wright in 1958. The Marin County supervisors settled on the Scettrini Ranch as the new site for the county complex, however, the acreage needed to be annexed so it could legally become the county seat. The supervisors reviewed designs from several local architects, but on the suggestion of county supervisor Vera Schultz and planning director Mary Summers, they contacted Frank Lloyd Wright. He accepted the commission, and plans were drawn up. The Administration Building shows the hand of Frank Lloyd Wright most clearly. The Hall of Justice shares design features with Wright and Aaron Green. Green's touches include the circular courtrooms. The Veterans' Memorial Theater was designed entirely by William Wesley Peters. The complex was immediately a tourist attraction, and Frank Lloyd Wright fans put San Rafael on their itinerary. Architectural students visit and tour the building to study the innovative designs that make the Marin Civic Center so unique. The building is both a California Historical Landmark and a National Historic Site.

In 1953, the Marin County Board of Supervisors decided it was necessary to build a new civic center to replace the old courthouse downtown on Fourth Street. The courthouse had long been inadequate for Marin County business; offices of county officials were scattered all over town in rented facilities. This disbursement of office space was a hindrance to communication. The Scettrini property was just north of San Rafael and would provide a single contiguous space for county employees. After some delays, it was purchased for $531,416 in 1956. This price covered the entire tract of 140 acres. The money had been accumulating in a special fund since 1952. Additionally, the board tapped into state money, which was set aside for county fairs and fairgrounds that were to be included in the civic center project. In this image, a Mobil gas station is visible on the corner of North San Pedro Road and San Pedro Avenue. This lot is still occupied by a gas station today, however the station on the opposite corner has been redeveloped into other businesses.

Several architects were interviewed to design the civic center project, but the board had no enthusiasm for their plans. Vera Schultz, Marin's first woman on the board of supervisors, brought up Frank Lloyd Wright's name and negotiated a meeting with him in San Francisco at the Frank Lloyd Wright Foundation offices. On July 29, 1957, Frank Lloyd Wright spoke at a public meeting held at San Rafael High School.

Frank Lloyd Wright was a controversial figure, and some objected to his selection as architect for the project. At the first meeting, a member of the American Legion accused him of being a communist. Wright responded by walking out of the meeting. Vera Schultz soothed his ruffled feathers and convinced Wright that most of Marin's residents were thrilled to have such an internationally recognized architect to design their civic center.

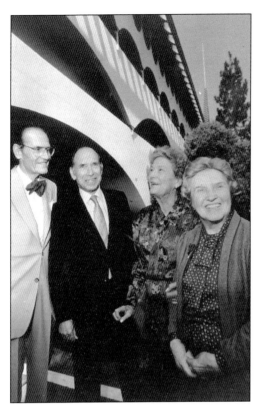

The 25th anniversary of the Marin County Civic Center was held in October 1987. A reunion of those who helped bring the building into being included many famous names. Seen on that occasion are William Wesley Peters, Aaron Green, Mary Summers, and Vera Schultz. Frank Lloyd Wright passed away before the completion of the civic center.

When Frank Lloyd Wright saw the site, he imagined the whole plan. He said, "I will bridge these hills with a series of arches." In accordance with his architectural philosophy, he wanted to blend the buildings harmoniously with the environmental surroundings. The two main buildings span three naturally occurring hills. He included many windows and skylights so the exterior's scenic beauty and light would transmit to the building's interior.

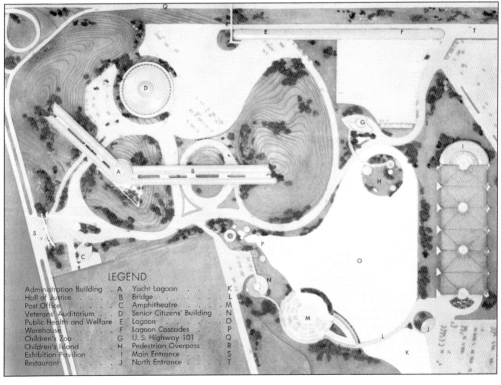

LEGEND

Administration Building	A	Yacht Lagoon	K
Hall of Justice	B	Bridge	L
Post Office	C	Amphitheatre	M
Veterans' Auditorium	D	Senior Citizens' Building	N
Public Health and Welfare	E	Lagoon	O
Warehouse	F	Lagoon Cascades	P
Children's Zoo	G	U. S. Highway 101	Q
Children's Island	H	Pedestrian Overpass	R
Exhibition Pavilion	I	Main Entrance	S
Restaurant	J	North Entrance	T

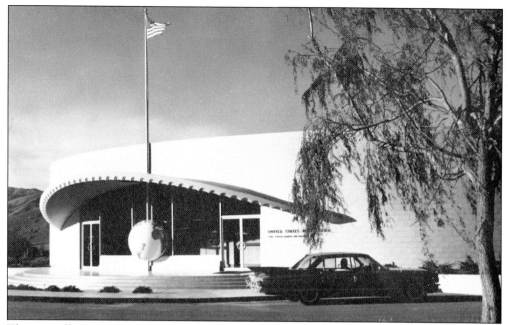

The post office was actually the first building constructed on the civic center site. Because it was so close to the new buildings, it was decided that Frank Lloyd Wright would design it. Originally, there was a globe half inside and half outside the building. Unfortunately, the globe was vandalized and never replaced.

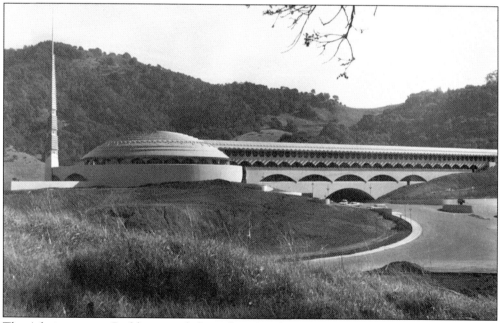

The Administration Building was dedicated on October 13, 1962. Dr. Theodore Gill, president of the San Francisco Theological Seminary, gave the dedicatory speech saying, "The residents of Marin . . . took a chance on art. The building has grace and dignity and power." Frank Lloyd Wright died on April 9, 1959, and never saw his creation. His widow represented him at the dedication and described the building "as the true spirit of the artist."

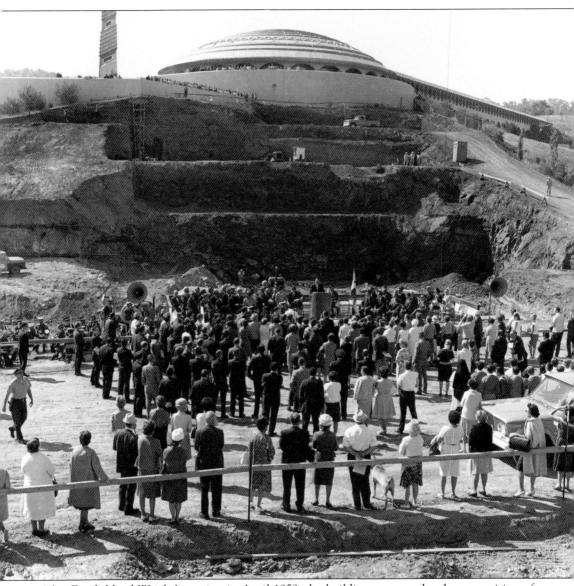

After Frank Lloyd Wright's passing in April 1959, the building came under the supervision of Frank Lloyd Wright Foundation architects William Wesley Peters and Aaron Green. In June 1960, supervisors Schultz and Marshall were defeated in general elections. A stop-work order was placed on the civic center's construction when the new board of supervisors decided to convert the site into a hospital. Marin residents were outraged. The *Independent Journal*, the local newspaper, ran a straw poll. Results showed 8,152 votes to 1,225 votes against the work stoppage. The new supervisors heard the voice of Marin residents, and construction on the new civic center proceeded. In 1965, a $7.7-million bond issue funding the construction of the Hall of Justice passed. The ground breaking was on May 25, 1966, and the Hall of Justice's cornerstone was laid a day later on May 26. By the end of 1969, the building was completed.

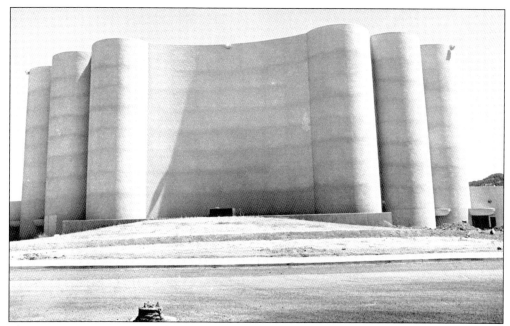

The Marin Veterans Memorial Theater was also a part of the civic center complex. Now known as the Marin Center, the building seats 2,003 in the audience and provides a venue for symphony, popular concerts, ballet, and lecture series. The theater and nearby lagoon are also part of the Marin County Fairgrounds, which moved from the Marin Art and Garden Center in Ross to the civic center in 1971.

Dedicated to Marin soldiers who died in World War I, this doughboy statue stood in front of the old courthouse until August 1971 when it took a trip to the Avenue of Flags just outside the Marin Center. Today, the doughboy is surrounded by other memorials: World War II, the Vietnam and Korean Wars, the Iraq and Afghanistan wars, and the American Merchant Marines.

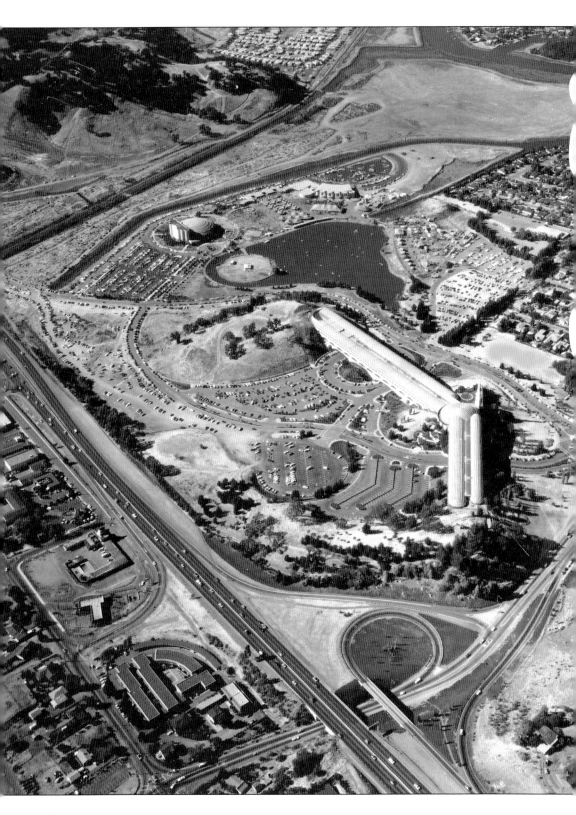

The completed civic center, seen here from the air, includes the
Administration Building, Hall of Justice, Marin Center, lagoon, and
fairgrounds. The completed civic center differs from the original sketches
created by Frank Lloyd Wright but includes most of the ideas from
his first inspiration. At the bottom of the image is Highway 101 with
northbound traffic heading left. North San Pedro Road runs vertically up
the right edge of the image. Marin County is fortunate to have a world-
class government building designed by one of the most notable architects
of all time. It has been named both a state and national landmark.

On August 7, 1970, Judge Haley died in a hostage situation that originated in a Marin County Civic Center courtroom. During the trial of San Quentin inmate James McClain, Jonathan Jackson entered the courtroom with a concealed weapon. He pulled the gun out from under his coat and took Judge Haley hostage. With the help of accomplices Ruchell Magee and William Christmas, Judge Haley, deputy district attorney Gary Thomas, and three jurors were taken from the courtroom. Jackson and the other kidnappers attempted to flee the courthouse with the hostages in tow, but law enforcement officers opened fire on their van. In the exchange of gunfire, Judge Haley, Jackson, McClain, and Christmas were killed. Thomas was shot, but the three jurors escaped unharmed. Judge Haley Drive and a memorial near the lagoon are dedicated in the judge's honor.

Eight

OUT WITH THE OLD,

IN WITH THE NEW

DESTRUCTION, PRESERVATION,

AND CONSTRUCTION

Visitors to San Rafael see many historic homes and buildings that connect the city to its past. This is because there was a concerted effort starting in the 1970s to value historic buildings. A cultural affairs committee was formed to survey architectural and historically important structures, such as the Rafael Theater and Dollar Mansion. San Rafael residents then took action to protect these treasures from being destroyed. However, some buildings were razed because the owners felt that they were no longer profitable or useful. Examples include the First Presbyterian Church, the old El Camino Theatre, and the brick barn in Peacock Gap. There has also been new construction. A new city hall replaced the old one, and the old Macy's building on Fourth Street was razed and replaced by a new mixed-use space. San Rafael today is not the same as San Rafael 50 years ago. Many of the historic buildings still stand near new additions, combining the past and present in a harmonious mix.

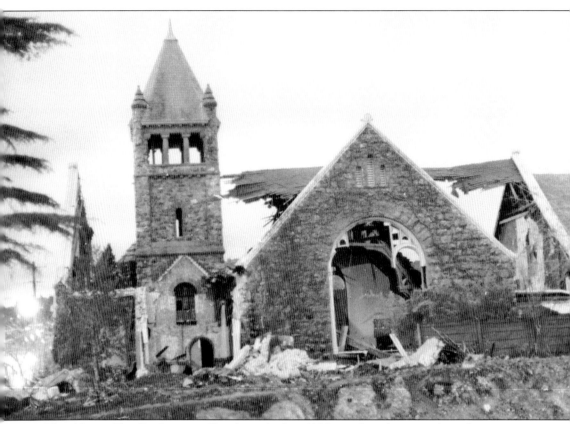

The old stone First Presbyterian Church was built in 1896 to replace the original wooden structure. The congregation voted to demolish the church in 1971 because of concern about its structural safety. The many memorial stained-glass windows were removed for inclusion in the new structure, and the new sanctuary was dedicated September 9, 1973.

The Sheehy Mansion at 820 Mission Avenue was demolished in 1974 because the former owner had specified in her will that the house be torn down. There was some objection by preservationists, but the reality was the home was no longer structurally sound and could not be saved.

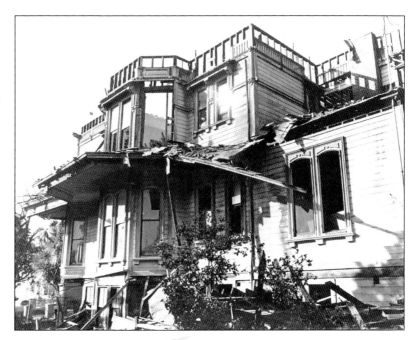

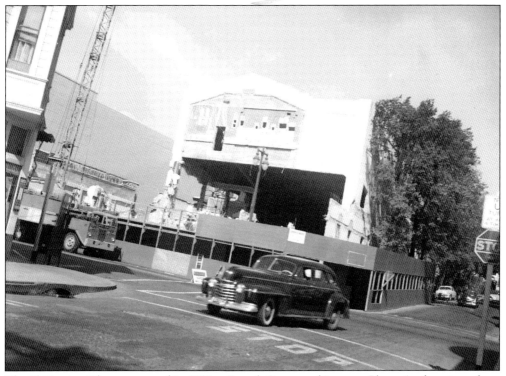

The El Camino Theatre opened in 1928 at Fourth Street and Lootens Place. At that time, there were only silent films. The theater closed in 1953 because there was not enough business for two theaters in San Rafael. The facade was removed, and the site was remodeled as a J.C. Penney store. Eventually, Macy's took over the space to expand its department store. After Macy's moved to the Northgate Mall, the store remained empty until it was remodeled in 2000.

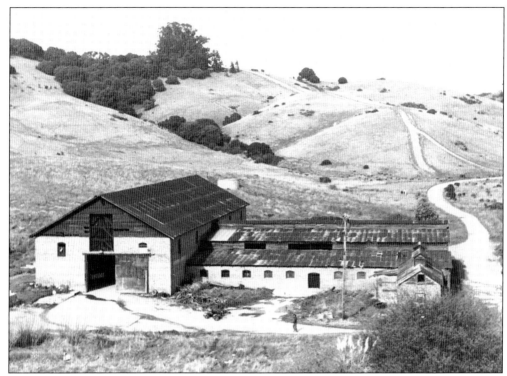

The McNear family's brick dairy barn was threatened when developers eyed the area for homes. Because of its historic significance, the community thought it should be preserved. It was offered to the Marin County Historical Society as its headquarters, but the cost of renovation was too high to accept the offer. Instead, the developer compromised by reusing the bricks to build townhouses in the footprint of the old barn.

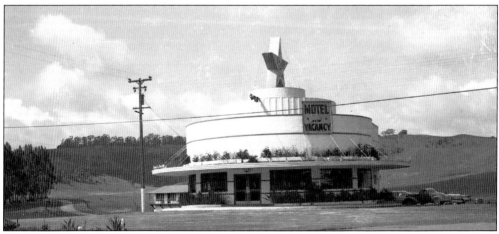

The Starlight Club began as an exhibit for a Chicken of the Sea canned tuna product at the 1939 Golden Gate International Exposition. After the exposition closed, the building was brought to Terra Linda in sections and set up as a restaurant and nightclub. Its unusual circular design topped by the huge white star made it a popular attraction. It was torn down in 1963.

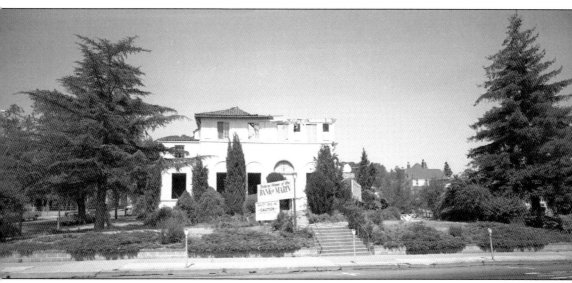

For 47 years, the Elks San Rafael Lodge No. 1108 was located on the corner of Fifth Avenue and B Street. The building was constructed in 1916, and by the early 1960s, the fraternal organization was ready for a new home. In 1962, they moved from Fifth Avenue to 1312 Mission Avenue into "Maple Lawn," Louise Arner Boyd's home, and the old Elks building was torn down. Prior to vacating the property, the Elks removed a beautiful stained-glass window depicting the emblems associated with the Elks. In this image, the building is being torn down by Ghilotti Brothers Construction Company. Notable is the Ghilotti Brothers caution sign under the "Future Home of the Bank of Marin" sign. Bank of Marin did construct a new building on this site and used it for a time, but now Westamerica Bank occupies the building.

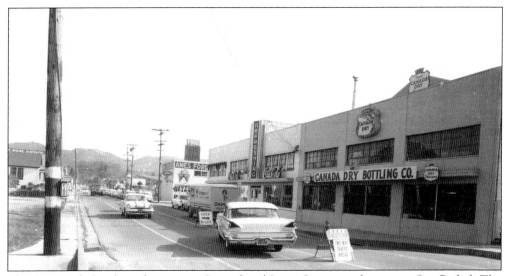

The Coca-Cola bottling plant was at Second and Irwin Streets in downtown San Rafael. The first president of the plant was Edmund Meyers, who had been the president of the Meyers Soda Water plant. Old Coca-Cola glass bottles can still be found today with "San Rafael" impressed on the base. The plant moved to Bel Marin Keys in Novato in 1969.

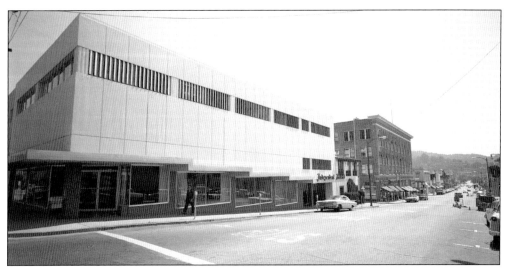

The *Independent Journal* newspaper constructed a new building, which opened on October 1, 1957, at 1040 B Street. Publisher Roy A. Brown took pride in the new state-of-the-art building. After the *Independent Journal* was sold to Gannett Corporation in 1979, the newspaper moved to new headquarters in Novato, leaving behind this building. A new office building was constructed on the site after the old structure was razed.

The old San Rafael City Hall on A Street was demolished in 1966. In this image, a Ghilotti Brothers Construction Company caterpillar makes short work of a house being removed in anticipation of the new city hall. Mayor C. Paul Bettini dedicated the new city hall on October 1, 1966. The new building cost over $1.7 million but was completely paid for at the time of the dedication.

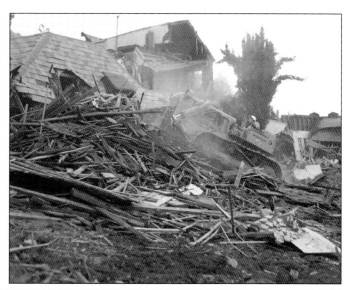

The memorial to veterans of World War I was one casualty of the move to the new San Rafael City Hall. The obelisk shattered as the moving crew tried to relocate it to a site near the new city hall.

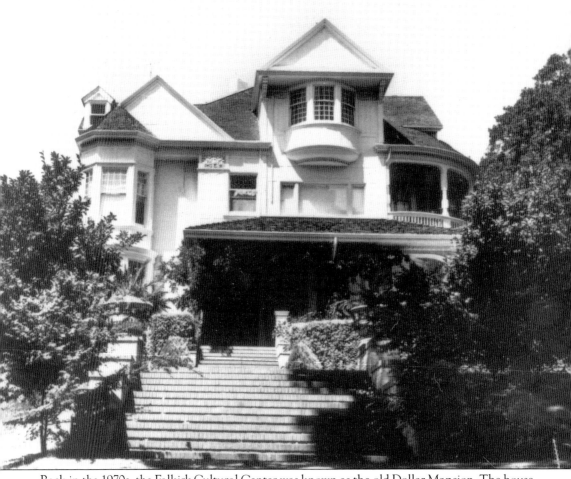

Back in the 1970s, the Falkirk Cultural Center was known as the old Dollar Mansion. The house was owned by the Dollar family, descendents of Capt. Robert Dollar who founded the Dollar Steamship Company. The family no longer wanted to live in the iconic old home, so it was scheduled to be razed by a developer. The developer planned to replace the Queen Anne–style home with a six-story condominium complex. A group of residents formed an organization called Marin Heritage to fight to protect the home from demolition. The residents of San Rafael voted to tax themselves to buy the house. Taxes were raised, and the house was saved. It became the Falkirk Cultural Center and has been owned by the City of San Rafael since 1978. Many volunteers in the community donate their time to help the city employees operate the center.

An inventory to identify historic homes and buildings of architectural and historic significance was completed in 1978. The inventory was conducted by the San Rafael Cultural Affairs Commission with the oversight of the architectural firm of Charles Hall Page and Associates. They identified 300 homes and buildings graded as good, excellent, and exceptional.

Whistlestop, an organization that provides services for the elderly and disabled, occupies the old Northwestern Pacific Railroad depot. Whistlestop purchased the building in 1980 and added a second floor to accommodate its programs in 1984. Multicultural activities were added in 1993 to help senior immigrants adjust to their new country. Whistlestop also runs the Meals on Wheels program that began in 1972 as well as transportation for seniors.

The 1938 Art Deco Rafael Theater was transformed in 1999 from a single-screen theater to three theaters that show independent films, foreign films, and documentaries. The renovation uncovered many of the hidden decorative features. The theater is home to the Film Institute of Northern California that runs the Mill Valley Film Festival, and the theater's revival has contributed to the revitalization of Fourth Street and downtown San Rafael.

In 1978, a developer refurbished five Victorian homes built between 1893 and 1896 on Irwin Street near Third Street. The developer determined it was cheaper to remodel the buildings than to construct a new structure. The new complex of buildings is called the French Quarter and is home to shops and offices.

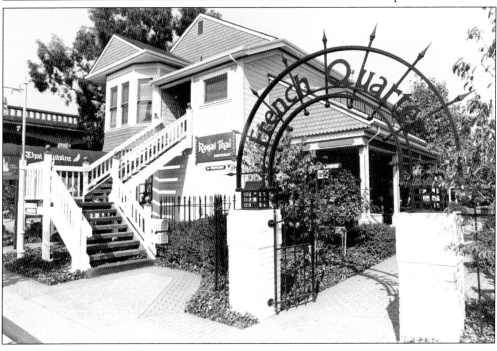

The old clock standing on Fourth Street's Courthouse Square was a gift to the city in 1973 by Cecelia Michael in memory of her husband, Roy M. Michael, a local businessman. The clock stood outside his business on Lootens Place. It was previously bought by Michael after the Fredericks jewelry-store owner offered it for sale. The clock has told the time in San Rafael for over 100 years.

The old Macy's/Albert's Building was demolished in 1999 to make way for a mixed-use structure with ground-floor retail space, upper-level offices, and apartments. The southern block of Court Street was closed and redesigned into an open plaza creating an inviting public space in downtown San Rafael. The San Rafael City Plaza opened in 2002.

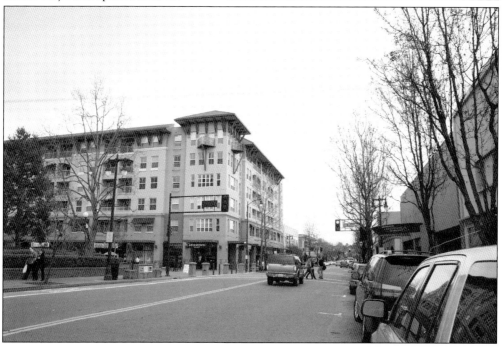

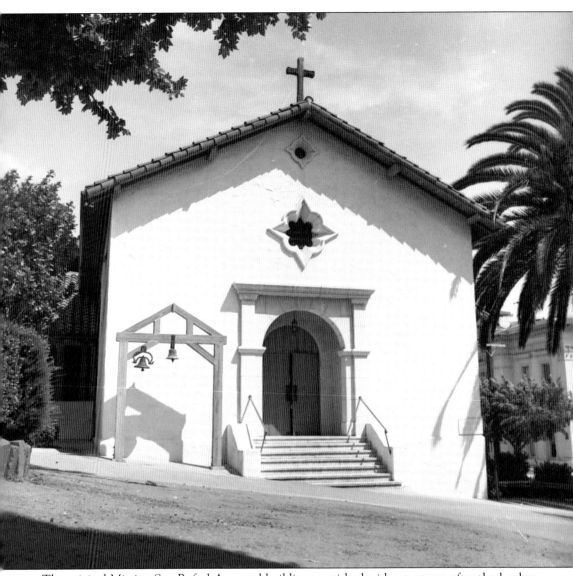

The original Mission San Rafael Arcangel buildings vanished without a trace after the lumber was removed in 1862 and the original adobe melted back into the earth. A movement to rebuild the old missions of California, including the Mission San Rafael, was spurred to action by an $85,000 grant from the Hearst Foundation in 1949. Work began on the replica on May 22, 1949, with plans drawn up by Arnold Constable of Sausalito. Constable was a noted architect who specialized in church building design. He also designed the Novitiate and Guzman Halls at Dominican University. The rebuilt mission is not a duplicate of the original because the details of the original have been lost to time. The most commonly known sketch of the original mission was done from Gen. Mariano Vallejo's recollection 30 plus years after he had last seen it. When the 1949 building was completed, there was a grand festival and parade.

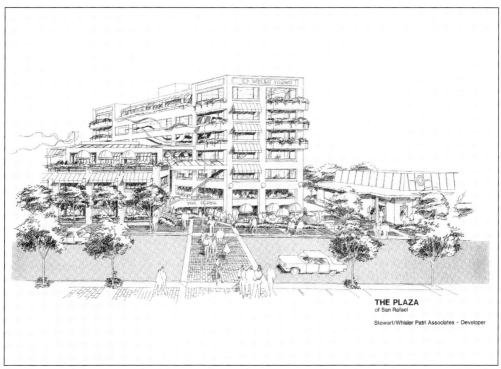

THE PLAZA
of San Rafael

Stewart/Whisler Patri Associates – Developer

Fire destroyed the existing building on the southeast corner of Fourth and A Streets, and the lot stood vacant for two years. After reviewing several proposals, the city's planning commission favored the design seen here by Stewart/Whisler Patri. Eventually, the structure was deemed too imposing and was scaled back to the semi-subterranean building that stands now on the corner.

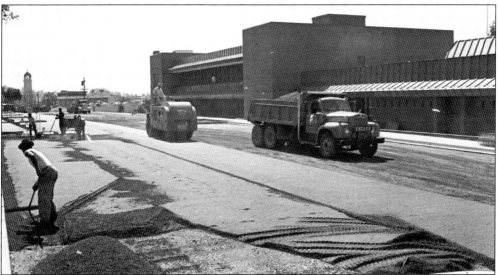

On July 25, 1966, the *Independent Journal* ran a full-page article with pictures about the new city hall. The new $1-million hall was quite an improvement to the cramped, 57-year-old building city employees had shared. The new building combined the police station and city hall offices into one 2.16-acre site. This photograph was featured along with others that showed the new hall's spacious, contemporary styling.

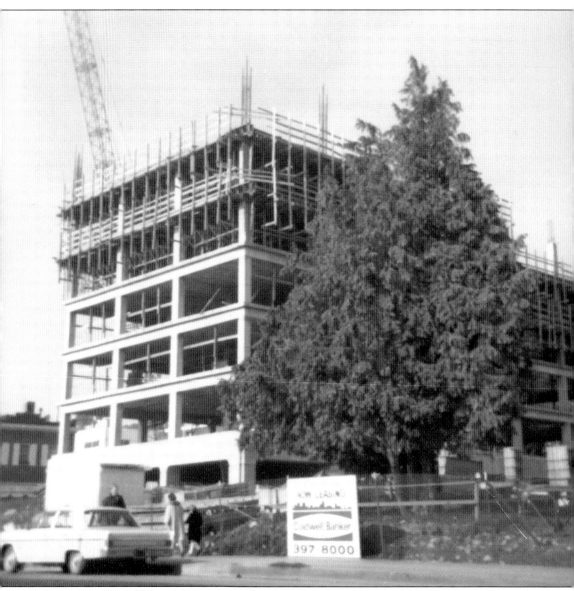

An arsonist burned Marin's historic courthouse to the ground on May 26, 1971. This photograph was taken midway through construction of the new building in 1973. The building, now a bank and offices, stands eight stories high, although only six of those eight floors are seen in this photograph. The height of this structure fueled concern regarding San Rafael's skyline, thus affecting buildings constructed after this one. A companion building was constructed on the lot east (to the right) of this one, and the two structures are joined by a common lobby. Over the doors is a sign that reads, "Courthouse Square 1000 Fourth Street." Many San Rafael and Marin residents remember the old courthouse fondly. At the end of the 20th century, Court Street (to the right of this image) was blocked off and turned into an open plaza.

96

Nine

SAN RAFAEL CARES

SOCIAL RESPONSIBILITY

The people of San Rafael care deeply about their city and the people who live there. The population supports many programs that help folks in need. St. Vincent's has been in San Rafael since the 1950s and opened the dining room to feed the hungry in 1981. The Ritter House is another facility that helps those who are disadvantaged. Since 1947, Guide Dogs in San Rafael has been providing dogs for the sightless all over the United States. The people of San Rafael are also on the forefront of caring for the wildlife and environment in the area. The establishment of WildCare not only helps to heal injured animals but also promotes better protection of wildlife and preservation of the remaining open spaces in the area. San Rafael concern for the environment is shown in the massive recycling efforts of the community. San Rafael could not be what it is today without the dedication and service of the men and women in the police and fire departments.

San Rafael police pose for a departmental portrait on the steps of the old city hall in 1952. Chief of police Frank Kelly is standing in the first row on the extreme right. He is posing with 19 of his fellow officers. Fifteen are patrol officers, three are desk officers who operated the radio, and one is a traffic clerk. At that time, there were two patrol cars with two-way radios and two motorcycles to help the policemen on patrol. The August 1944 *Police and Peace Officer's Journal* noted Chief Kelly was one of three Bay Area police chiefs to attend the FBI's summer semester police academy in Washington, DC. FBI director John Edgar Hoover notified Kelly through Mayor William Nock that "he is the first representative to the famed police school to come from Marin County." The record goes on to state, "This honor is largely due to Chief Kelly's reputation for law enforcement, reorganization of the Police Department . . . and his faithful performance of his duties."

The San Rafael Fire Department, seen here on the corner of C Street and Fifth Avenue, still stands. It was built in 1917 so by the mid-1980s needed to be upgraded. In 1987, it was remodeled by adding space to the right of this building. The building in this image still closely resembles the remodeled structure with the exception of the bell on the roof. In the era of this photograph, there was one fire station in San Rafael with 250 hydrants and 15 paid firefighters as well as a host of volunteers. The first full-time fire chief, Fred Scheuer, was hired in 1945, and the San Rafael Fire Department celebrated 126 years of service in 2000. Over the course of those years, the fire department's emphasis has shifted from fire suppression to fire prevention. This in part is because of improved building codes and the invention of the fire detector.

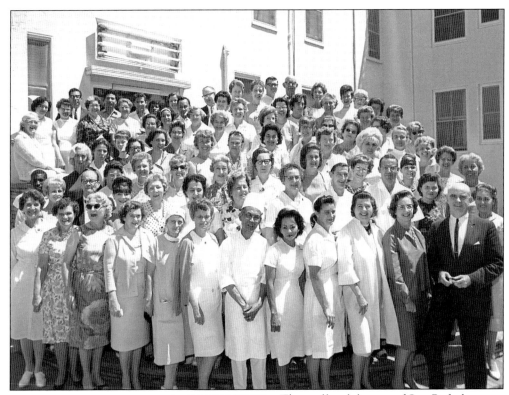

The staff and doctors of San Rafael General Hospital are standing on the steps fronting Nye Street. In 1946, John K. Taylor bought the hospital from Mr. and Mrs. Dias, and the name changed from Cottage Hospital to San Rafael Hospital. In the latter half of the 20th century, the building was significantly remodeled and no longer resembles the hospital. San Rafael Hospital closed in 1967.

Marin County purchased land on Lucas Valley Road in 1880 to provide for the care of the sick and elderly who had no means to support themselves. The hospital was completed in 1913 to provide for convalescing patients and those who were too ill to work. The surrounding farm provided dairy products and crops for sale as well as supplying the table for the patients. The buildings, however, began to deteriorate in the 1950s, and the Marin County Farm and Hospital was closed in 1963 and the structures torn down. Nearby now is juvenile hall and Rotary Valley Senior Village.

In 1959, Kay Sampson worried that the stockpile of polio vaccine would become outdated if more San Rafael residents did not get their polio shots. Polio was a serious disease that left many people paralyzed for life. Before the Salk vaccine was invented in 1955, summer activities were often shut down for fear of a polio epidemic. Now the vaccine is regularly given to children, and few incidents of the disease occur.

The Red Cross has been in Marin County since 1898. Mrs. Edwin Newhall donated the land and an ark to the Red Cross. The ark is still there at 712 Fifth Avenue, sandwiched between two additions added in 1941. The Red Cross offers first-aid training, water safety, and shelter for victims of fire and flood.

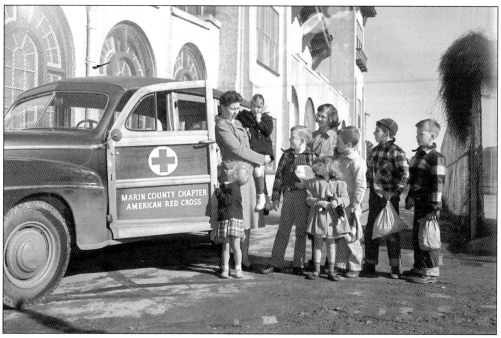

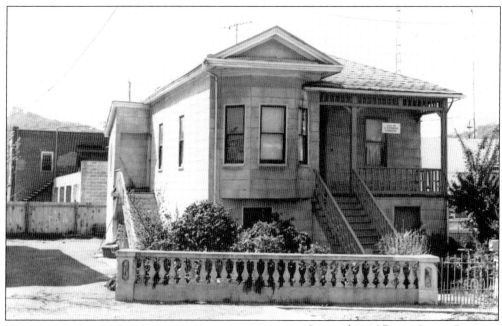

Located at 16 Ritter Street, Ritter House started out as a family home. This little house has become a one-stop help center for the homeless and those at risk of becoming homeless. The center provides food, clothing, and furniture as well as a place to shower, a postal address, and phone service. Originally called the Human Concerns Center, the name was changed in 1997 to reflect the original family name.

St. Vincent de Paul Society opened a thrift shop on B Street in 1952 but soon found a greater need in feeding the homeless and working poor. In 1981, the society opened a free dining room at 820 B Street and began offering free meals to anyone who showed up. Although some merchants have grumbled about their clientele, the program is supported by the San Rafael community and its churches.

The old St. Paul's Episcopal Church guild hall was moved to 76 Albert Lane in 1954 and became the Junior Museum. In 1969, the name changed to the Louise Boyd Marin Museum of Science and then in 1977 became the Marin Museum of Natural History. Now known as WildCare, the emphasis is on education regarding wild animals and wildlife rehabilitation for injured, diseased, and orphaned animals and birds.

Guide Dogs for the Blind was founded in 1942 to help wounded servicemen returning from World War II. In 1947, it moved to an 11-acre campus in Terra Linda. Puppies are fostered in private homes until they are 14 months old when they are returned to be professionally trained by the organization. The dogs help legally blind people throughout the United States and Canada at no charge.

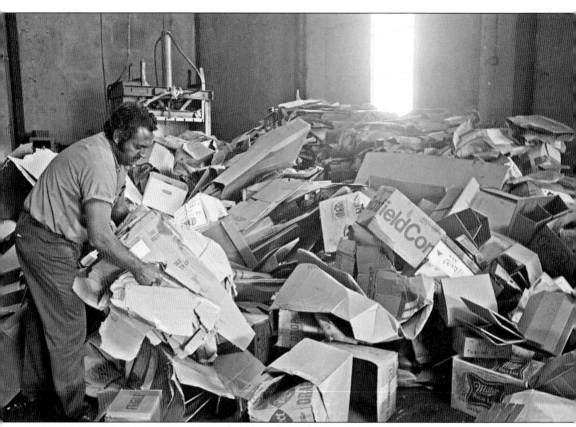

In 1973, Joe Garbarino sorts through old cardboard boxes collected by Marin Sanitary Service before sending them to a recycling center in Emeryville. Tons of cardboard and newspapers, like these, were collected each week and recycled. This was the beginning of a new trend that now includes recycling metal, glass, plastic, green materials, and paper. When Marin Sanitary Service started a decade and a half earlier, the residents of Marin County were sending over 90 percent of their waste to the landfill. Many San Rafael residents remember "the dump," which was on East Francisco Boulevard midway between downtown and the Richmond–San Rafael Bridge. The Marin Sanitary Service has grown to include a new complex and in the mid-1990s was granted a franchise for additional unincorporated areas around San Rafael. Over the course of their 50 years in business, the Garbarinos have nearly reversed the landfill-to-recycling ratio and now are leaders in recycling efforts.

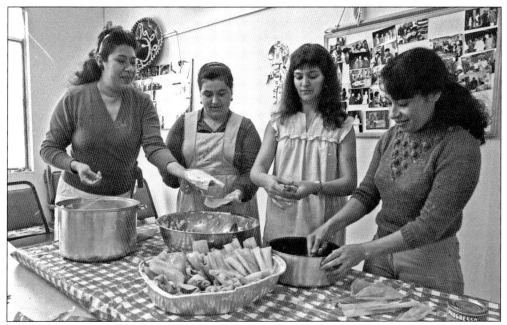

La Familia was founded in the 1970s to help the growing number of Hispanic immigrants adjust to life in the United States. The organization also tried to teach the Spanish language and Latin culture to residents who were interested. As the percentage of Spanish speakers in Marin rose, the need for such an organization was obvious, but problems in the leadership caused the organization to disband.

Aldersly was founded in 1921 by Danes from California and Nevada as a retirement home for their community's elderly. Since then, the home has expanded care to include all nationalities, enhanced the facilities, and been honored by visits from Danish royalty. Aldersly, Danish for "shelter for the aging," celebrates with traditional food, drink, music, and dancing at the annual Tivoli Festival, named for the famous Copenhagen amusement park.

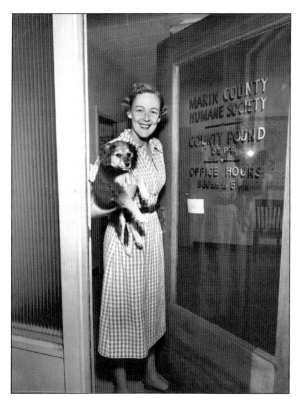

Founded in 1907, the Marin County Humane Society rented a small storefront fitted with handmade cages. In 1949, the Humane Society became the official pound agency for the county, and a new animal shelter was dedicated at Third and Mary Streets in June 1951. In 1963, the Humane Society bought eight acres in Ignacio and built a complex that still serves as a shelter and education and adoption center for pets.

Archaeologist Charles Slaymaker's work in the late 1960s on Miller Creek School's Indian Mound led to the preservation of this Coast Miwok village called Cotamkotca, or "grasshopper houses." This sweathouse was reconstructed for the edification of the public. The site is now surrounded by fencing for its own protection and in October 14, 1971, was added to the National Register of Historic Places.

Ten

TIME TO PLAY

SAN RAFAEL HAS FUN

San Rafael is a place where people make the most of life. The many festivals and celebrations over the years have united the community with a sense of togetherness. From the earliest days of San Rafael, there have been cultural celebrations, such as the San Rafael Fiesta Days, and patriotic celebrations, such as the annual Fourth of July parade that brought the crowds to Fourth Street in downtown. Today, that celebration takes place at the county fair at the Marin County Civic Center. Top-name musical acts and fireworks are the highlights of the fair. San Rafael is home to many Italian immigrants, and they have preserved their culture with bocce ball leagues in Albert Park. While the parades have given way to more modern celebrations, there are still plenty of opportunities for the community to come together. The farmers market and May Madness are just two examples of this. The city also enjoys the diversions that are found in most cities: movie theaters, music, and sporting venues are all part of what makes San Rafael a vibrant community.

12th ANNUAL
OLD SAN RAFAEL

FIESTA DAYS

OCTOBER 11-12-13-14-15

VICTORY EDITION
SOUVENIR PROGRAM

SPONSORED BY:
MARINITA PARLOR, NO. 198
NATIVE DAUGHTERS OF THE GOLDEN WEST

San Rafael's Fiesta Week was originally established to celebrate the Feast of the Archangel Rafael on October 24, in whose honor the city of San Rafael was named. Over the years, the celebration changed, gradually including only private parties and barbecues among the old-timers. However, in 1934, the citywide celebration was revived on the 150th anniversary of the death of Fr. Junipero Serra. Serra founded California's mission chain, which includes Mission San Rafael Arcangel on Fifth Avenue. San Rafael's Marinita Parlor of the Native Daughters joined the Grand Parlor in other mission communities in observing the anniversary. The local parlor held a two-day Serra Fiesta and the next year brought San Rafael Fiesta Days back to life. The last Fiesta Days sponsored by the Native Daughters was in 1952. Other Fiesta Days have flourished over the years and continue today.

February 18, 1974, marked the 100-year anniversary of San Rafael, Marin's first self-governing municipality. In May, the city honored its centennial with a 10-day celebration, ranging from a centennial ball to a parade down Fourth Street. The city was decked out in blue-and-gold centennial signs. A musical production jubilee, depicting events in the city's 100-year history, was written and produced for the event.

In 1971, the Marin County Fair moved from the Ross's Marin Art and Garden Center, where it had been held for the past 25 years, to the newly developed fair pavilion at the Marin County Civic Center. In 1971, fairgoers were entertained by local ballet and dance groups. Over the years as the fair evolved, it has hosted many top-name performers and added a midway with games and rides. (Photograph by John Starkweather.)

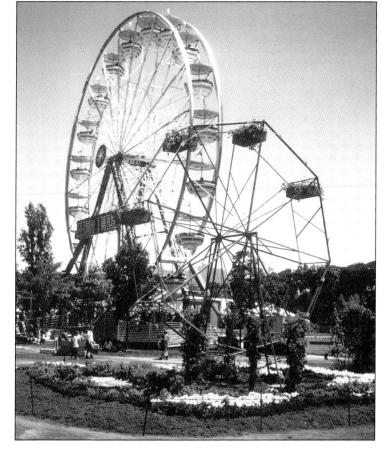

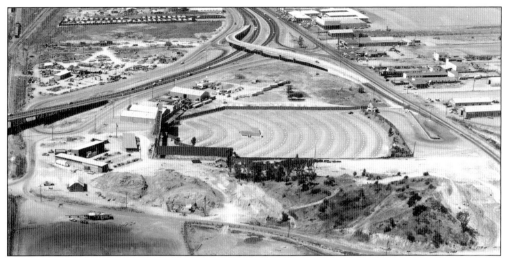

Many Marin residents have fond memories of pulling into Marin Motor Movies and watching the big screen from the front seat of their car. Marin Motor Movies opened on May 21, 1948, and could accommodate up to 600 automobiles. The screen backed up to Highway 101, leaving late-night commuters guessing at what was projected on the big screen. After closing down, the drive-in fell into disuse and the bulldozers where brought in. In its place, a new shopping center was built. Known as Marin Square, the shopping center has been doing business since 1984, and its footprint still faintly resembles a drive-in theater. The above image is an aerial taken on September 4, 1955, where in the background the convergence of Highways 101 and 580 is visible. The image below shows the shopping center under construction.

The longest running street-rod show and parade takes place each May in downtown San Rafael. Hundreds of classic automobiles, custom hot rods, and vintage roadsters are on display as thousands of spectators come from throughout the Bay Area to view these classic street machines of yesteryear, cruise the main drag of Fourth Street, enjoy food and drink, and move to some great dance bands.

Introduced in 1994, the Italian Street Painting festival has brought painters from around the world to San Rafael. The streets around Mission San Rafael are covered with hundreds of chalk paintings as professional artists, youth artists, and little children become *madonnari* (Italian for "street painters") and create works of art on asphalt. The festival benefits Youth In Arts, which brings art education into North Bay classrooms.

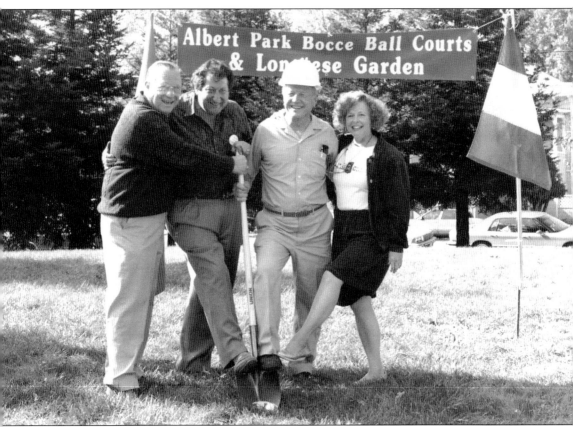

In June 1994, the first outdoor synthetic bocce courts in the country opened in San Rafael. The courts are in Albert Park on B Street, adjacent to the community center. Bocce ball is generally considered the Italian equivalent of British lawn bowling or French *pétanque* and is played with eight large balls and one smaller ball, the pallino. The pallino is thrown first followed by the larger bocce balls. The purpose of the game is to get the bocce balls as close as possible to the pallino. It is a perfect fit for San Rafael's Albert Park because it sits next to Little Italy, where many people from San Rafael's sister city Lonate Pozzolo, Italy, settled when they first came to America. The facility has grown to 10 courts, two of which are located inside the building, while the remaining eight are outside near barbecues and picnic tables. The Marin Bocce Federation runs the courts and encourages league play as well as walk-ins and family games.

New Year's Eve 1999 was time for a huge party in San Rafael. The invitations were engraved, the party was a black-tie affair, and a concert was headlined by Grammy Award winner Bonnie Raitt, Jerry Lee Lewis, and local legends Huey Lewis and the News. The *Los Angeles Times* listed the party as one of the 99 places to be on New Year's Eve and even ABC's Peter Jennings planned to feature San Rafael's New Year's Eve party on national television. However, the crowds did not turn out, and the city lost over $1 million on the event. Tickets sales were less than projected, partially because of the Y2K scare and national warnings about terrorism. San Rafael city manager assured residents the loss would not cause a cut in services, but rather would come from a budget surplus accumulated during the city's recent booming economic times.

Since the early 1980s, the Marin Farmers Market has been operating at the Marin County Civic Center. The market is open on Thursday and Sunday mornings. These two markets are operated by the Agricultural Institute of Marin (AIM) and are the organization's oldest (Thursday) and largest (Sunday) farmers market. Both are celebrated community events where regional farmers, food purveyors, and artisans bring their best to sell directly to the public.

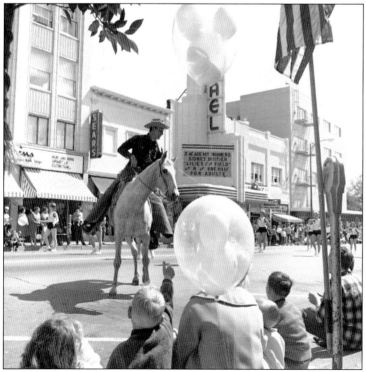

Through the years, San Rafael has hosted various May Day celebrations. In 1965, a parade was held in downtown San Rafael for the first time in eight years. In 1981, the May Faire was held in downtown San Rafael. Free entertainment, an arts and crafts festival, and a major fashion show were among the many activities that were part of this community spring celebration.

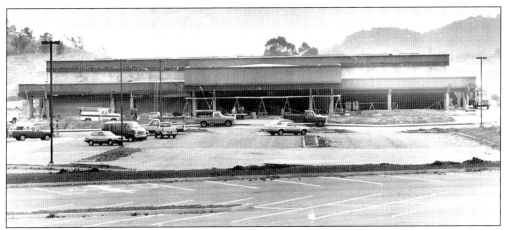

San Rafael's Regency Theater was under construction in October 1983 when this photograph was taken for the *Independent Journal*. This cinema houses six screens in one building and heralded in the age of multiplexes. Multiplexes became popular in the 1970s sometimes by converting an existing large theater into several smaller theaters. This building on Smith Ranch Road was erected specifically to accommodate six screens and large groups of moviegoers.

The Country Club Bowl opened on September 2, 1959, as a small resort. Besides the 40-lane bowling alley, there was a swimming pool surrounded by palm trees, billiard room, restaurant, cocktail lounge, dance floor, and tots nursery. Today, the swimming pool is gone, but owner John Masberg says there are 20 bowling leagues that bowl and enjoy the new game room, restaurant, and bar.

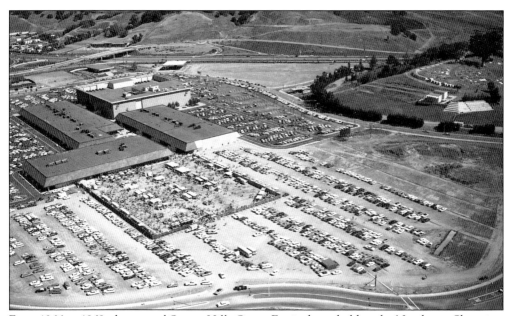

From 1966 to 1969, the annual Sunny Hills Grape Festival was held at the Northgate Shopping Center in Terra Linda. The festival started in 1899 when several Sunny Hills volunteers were looking to raise funds for the agency. The festival was held annually for over the 100 years, occasionally moving to a new location. To this day, Sunny Hills Services provides treatment and services to at-risk children and their families.

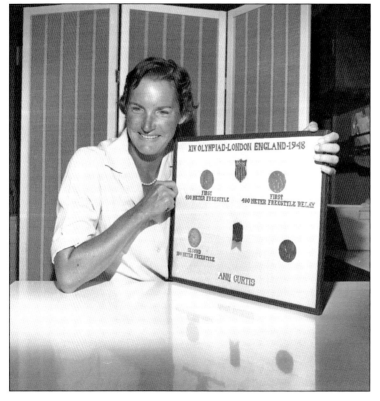

American competitive swimmer Ann Curtis participated in London's 1948 Olympic games, winning gold medals in the 400-meter freestyle event and freestyle relay plus a silver medal in the 100-meter freestyle. In 1966, she was inducted into the International Swimming Hall of Fame. Following this recognition, she returned to the Bay Area and opened a swim school in San Rafael that still operates today.

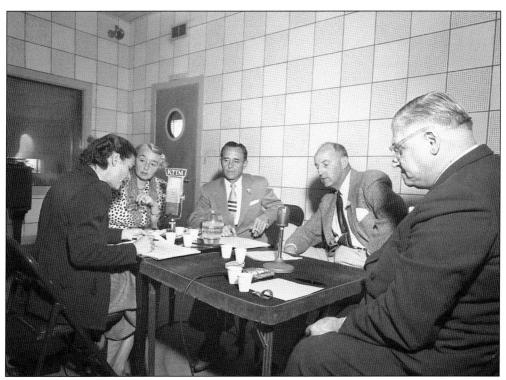

KTIM broadcast on both AM and FM in the 1970s and 1980s. Memorable disc jockeys include Dusty Street, Bobby Dale, and Bob McClay. KQED's Forum host Michael Krasney began his career on KTIM with a program called *Beyond the Hot Tub* where he interviewed local musicians like Jerry Garcia and Grace Slick. This schedule was published in the local newspaper for May 8–9, 1955, and is a good illustration of KTIM's programming range. On Sunday, May 8, programming started at 7:30 a.m., ended at 7:00 p.m., and featured many religious programs. On Monday, May 9, the programming focuses on music and entertainment, including Marin Man on the Street at 12:30 p.m. Some say the call letters, KTIM, stand for "K Tune In Marin," others argue, "K This Is Marin."

Radio Station KTIM

SUNDAY PROGRAM
Sunday, May 8, 1955
1510 Kilo

7:30—Sign on
7:31—Gospel Traveler
10:00—Parade of Pops
10:30—Echoes of Rose Manor
10:45—Parade of Pops
11:00—Christian Science Church
12:00—Terra Linda Northbay Tabloid
12:30—Rebroadcast—Sounding Board: Is the Calif. State Supreme Court's new ruling regarding illegally obtained evidence, in the public interest?
1:30—Report From Youth
1:45—Parade of Pops
2:00—Songs of Home
2:15—Parade of Pops
2:30—New Bethel Church
3:00—Parade of Pops
3:30—A Light Unto My Path; First Baptist Church;
3:45—Sacred Heart Program
4:00—Parade of Pops
4:30—Bethlehem Missionary Baptist Church
5:30—Parade of Pops
6:45—Treasury Show
7:00—Sign Off

MONDAY PROGRAM
May 9, 1955
1510 Kilo

7:00—Country Lee Crosby
7:30—Coffee & Donut News
8:00—Country Lee Crosby
8:30—Five Golden Moments
8:35—Polka Time
8:45—KTIM Newspaper of the Air
9:00—Music You Want
10:00—Agnelo Clementino
10:40—North Bay Music Shop
11:00—Kitty Oppenheimer
11:30—Today's Top Tunes
11:45—J. B. Rice's Swap Shop
12:00—KTIM Newspaper of the Air
12:15—Luncheon with KTIM
12:30—Marin Man on the Street
12:45—KTIM Hit Parade
1:00—Scratchy Nostaglia
1:30—Northbay Musical Journal of the Air
2:00—KTIM Newspaper of the Air
2:15—Northbay Musical Journal of the Air
3:00—Million Dollar Bandstand
4:00—KTIM Newspaper of the Air
4:05—Pete Harrison Western
5:00—Lee Crosby Hambone Stomp
5:45—KTIM Newspaper of the Air
6:00—Rebroadcast Man On Street
6:15—Evening Music
8:00—Sign off

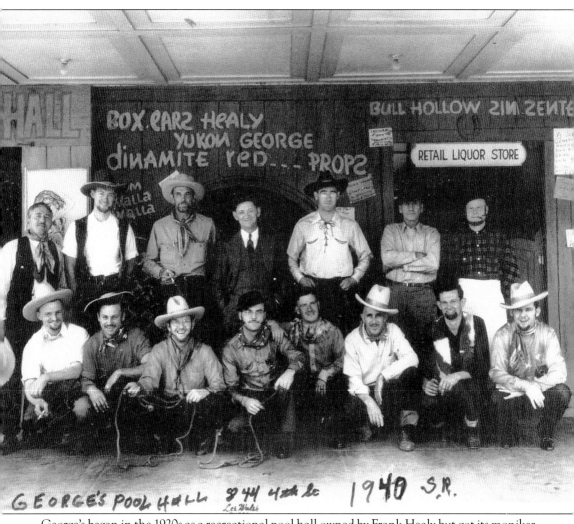

George's began in the 1920s as a recreational pool hall owned by Frank Healy but got its moniker from George Lefevre who owned the operation for several decades. The above photograph by Les Walsh Photo Studio was taken inside George's in 1940 and shows some of the colorful atmosphere therein. On the right edge of the photograph, a sign reads: "A SASSY General Haircutting All Sizes Bring Your Own POT." In the late 1940s, Lefevre remodeled the venue to include a bar, bowling alley, and poolroom. Starting in the late 1970s, the bar saw several owners and soon after was renamed New George's. After Uncle Charlie's in Corte Madera closed, New George's was widely considered the last great rock-and-roll venue in the county. Local musical legends who played New George's include the Grateful Dead, Jefferson Airplane, Santana, Chris Isaac, and Huey Lewis and the News.

Flutist David Wilkinson (age 17) and oboist Marsha Lang (age 18) play for fellow award winners Paul Kent (age 14) and Kenneth Bott (age 14). All four musicians plus Lois Clymer (age 17) won a $200 Marin Music Chest scholarship in August 1965. The Marin Music Chest was founded in 1933 by Maude Fay Symington and friends and has since been awarding scholarships to outstanding students in the county to further their musical educations.

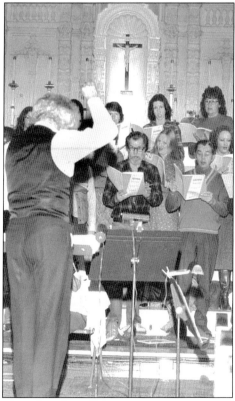

This image, published in Friday's December 9, 1981, edition of the *Independent Journal*, shows maestro Sandor Salgo leading members of the Marin Symphony Chorus in Vivaldi's *Gloria*. The group is rehearsing in the chapel at the St. Vincent's School for Boys and planned two performances that included choral works and concertos the following Sunday.

Marin Ballet was founded in 1963 in the private home of Leona Norman, a talented international dancer. The school grew under her guidance, adding students and expanding into a larger space. With the help of a generous grant from the S.H. Cowell Foundation in the early 1970s, the school was able to purchase a building in San Rafael's historic Dominican area. The building was originally a chapel and dormitory for the St. Peter Chanel Marist Fathers Seminary but was renovated and expanded to include six dance studios, a theater, a dance library, and several dressing rooms. The Marin Ballet is well known for performing the *Nutcracker* at the civic center's Marin Veteran's Auditorium. In 1987, the ballet company and George Lucas's special effects company, Industrial Light and Magic (based in Marin), partnered to enhance the annual *Nutcracker* performance. By 2000, dancers from the Marin Ballet have delighted audiences with the *Nutcracker* for over 30 years in a row.

There was a time when fishing in the canal was fun activity. Sadly, the canal had become a dumping ground for the many business and industries in the area over the years. Fishing is no longer a popular activity. Since 1923, when the canal became a federally authorized project, it has been dredged every five to seven years. Dense urban development on former tidal wetlands had constricted San Rafael Creek and reduced the ability of the channel to flush sediment out and maintain channel capacity as part of the tidal cycle. As of 2000, the canal had not been dredged since the spring of 1992. This caused a large buildup of silt and debris. The canal should be no shallower than six feet at low tide according to federal guidelines. However, low tide leaves just one foot of water, not even enough for the city's police boat to lend assistance in case of an emergency.

This iconic soda fountain was opened in 1947 as a retail outlet for Borden Dairy products. Borden had expanded to the Bay Area and was rapidly becoming nationally recognized. At the same time, the company acquired several of the nation's leading ice cream companies, making this soda fountain the perfect place to enjoy an ice cream sundae, a milk shake, or an ice cream cone. It proved a popular spot with local students from San Rafael High School before school and after classes. To this day, many alumni from there have fond memories of sitting on those pink-and-yellow stools drinking malts.

In 1926, when the Marin Rod and Gun Club was first formed, their membership numbered just 35, and they concentrated their efforts on conservation. Since then, the membership has grown to over 1,200, and their mission remains the same. The Marin Rod and Gun Club is situated near the foot of the Richmond–San Rafael Bridge and actively promotes the statewide conservation, preservation, and propagation of fish and game through its activities. When the clubhouse was completed in 1956, it was recognized in local newspapers as being "one of the finest sportsmen's club houses in the country." The article goes on to say, "At the present time landscaping tops the agenda and the club house grounds are expected to be a showplace of Marin." In addition to the clubhouse, members enjoy 55 acres of shoreline and the half-mile-long fishing pier. The club's pier is distinctive and can be seen from the westbound lanes of the Richmond–San Rafael Bridge.

Gerstle Memorial Park is a six-acre parcel once owned by the Gerstle family. Hannah Gerstle's heirs gave the property to the City of San Rafael. Paved, brick-bordered paths wind among spacious lawns and flower beds beneath a variety of large, beautiful trees, many shading picnic tables. Basketball and tennis courts as well as playgrounds and a picnic area make this park a delight for San Rafael residents.

Unique to Albert Park is its lighted baseball and softball fields, grandstands, and dressing rooms. Other facilities include four lighted tennis courts, archery range, bocce courts, horseshoe pits, an extensive children's playground, and basketball, handball, and volleyball courts. Development of the park was financed by a $180,000 bond issue approved by the city's voters in 1948.

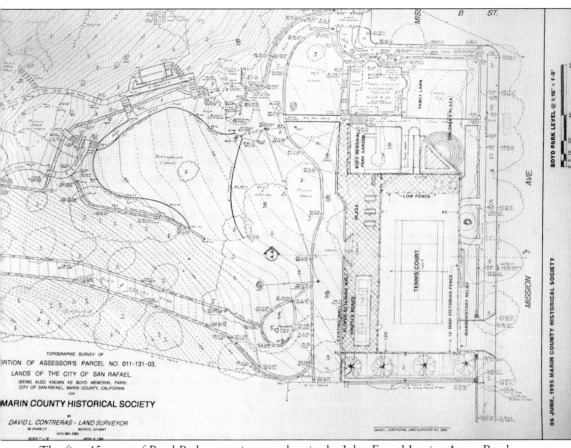

The first 15 acres of Boyd Park were given to the city by John F. and Louise Arner Boyd as a memorial to their sons Seth C. Boyd and John F. Boyd Jr. Later, 19 acres were added as a gift of Capt. Robert Dollar. John Boyd purchased additional property and removed some structures to enlarge the park grounds from the gates at the top of B Street to the top of San Rafael Hill. A gently graded path led to the summit with concrete benches placed at resting places along the way. Each bench had a name: Over-Look, Oakwood, Bide-a-Wee, Bonnie Brae, and more. The bench at the top was called Hillcrest and had a marvelous view of San Rafael and the San Francisco Bay. In the 1990s, the park's lower portion was redesigned. However, the plan was never fully implemented. Even so, the park still welcomes visitors with picnic benches, inviting grassy play areas, and a castle-themed play structure for children. Visitors can still hike to the top of the park and enjoy the view.

The Pickleweed Park Community Center opened in 1984 after Canal residents urged city leaders to build a park. Located at 50 Canal Street in the Canal neighborhood, Pickleweed Park is the newest of four community centers. Most of the funding came from the city through various grants and monies designed for park development. In 1993, the park and playground areas were upgraded, and two full-size soccer fields were installed in 2001. (Photograph by John Starkweather.)

Recently, the City of San Rafael honored longtime environmental activists Jean and John Starkweather by renaming Shoreline Park in their honor. Jean identified and preserved the city's bay wetlands against the proposed freeway from the foot of the Richmond Bridge along the shoreline to China Camp, and John served on the city's planning commission for 12 years. The Starkweathers' leadership demonstrates the importance of balancing development with the environment. (Photograph by John Starkweather.)

DISCOVER THOUSANDS OF LOCAL HISTORY BOOKS FEATURING MILLIONS OF VINTAGE IMAGES

Arcadia Publishing, the leading local history publisher in the United States, is committed to making history accessible and meaningful through publishing books that celebrate and preserve the heritage of America's people and places.

Find more books like this at
www.arcadiapublishing.com

Search for your hometown history, your old stomping grounds, and even your favorite sports team.

Consistent with our mission to preserve history on a local level, this book was printed in South Carolina on American-made paper and manufactured entirely in the United States. Products carrying the accredited Forest Stewardship Council (FSC) label are printed on 100 percent FSC-certified paper.